THE **SMARTPHONE PHOTOGRAPHY** GUIDE

SHOOT • EDIT • EXPERIMENT • SHARE

PETER COPE

CARLTON BOOKS

CONTENTS

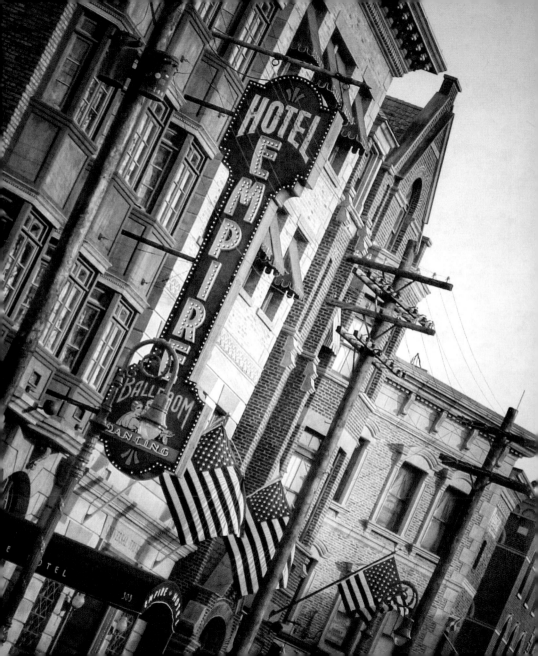

INTRODUCTION

We all love photos. Photos of friends, places we've been, things we've done. They help us share experiences and memories.

For much of the history of photography, taking photos was not something most people would even consider. Yes, there were enthusiasts, happy to carry around cameras (that weighed much the same as a small child) and labour long to get a good shot. But for the rest, their brush with photography would be a family portrait at a professional photographer's studio. There they would sit, stiffly, for a formal sitting.

Things began to change in the early twentieth century when George Eastman, the American inventor and entrepreneur – and founder of the company ultimately known as Kodak – came up with the Box Brownie camera. Photography could be big – really big – he suggested, but for it to be widely embraced by everyone, cameras needed to be light, portable and, most of all, easy to use.

For those aspiring photographers put off by the complexity and mystery of the photographic process the Box Brownie was a winner. The slogan used to launch the camera, 'You press the button, we do the rest', has gone down as one of the most potent in advertising history.

The camera had come of age. It had moved into the mainstream consumer market. As well as creating buoyant sales for Kodak and its contemporaries, a competitive marketplace drove innovation, creating all manner of cameras for all kinds of people. The camera manufacturer's dream was for everyone to own one, but for now they would have to be satisfied with a level of sales that approached one camera per family. Still, a remarkable achievement.

And that's the way things stayed for many years. Sales grew and fell though, overall, the number of cameras in circulation remained pretty constant.

The manufacturer's one camera per person dream would be eventually be realized, although

through an entirely different route. That route, of course, was via the smartphone. On board a device that everyone – or almost everyone – would carry with them all the time.

Though some would argue it was not the first smartphone (and less-than-smart-phones had inbuilt cameras for some years previously) this new age of photography was launched in the summer of 2007 with the arrival of Apple's original iPhone. Now let's be honest. The camera on that smartphone was okay. No more. And as a smartphone the early adopters were more likely to use it for web surfing and email. And music. And downloading apps. Little programmes that extended or transformed the functionality of the smartphone further. The camera element was an afterthought.

Though no one really bought the first iPhone as a camera, the photo opportunities it offered were soon realized. With the iPhone you could take a photo and not just display it immediately but send it via an email or message equally fast. Very soon you'd be able to post them easily to a Facebook page or Twitter. All technologies that, partly due to the smartphone, were in the ascendant.

Since then the smartphone hasn't just made taking photos really popular, it's helped develop new styles and trends where traditional virtues such as image resolution or quality are less important

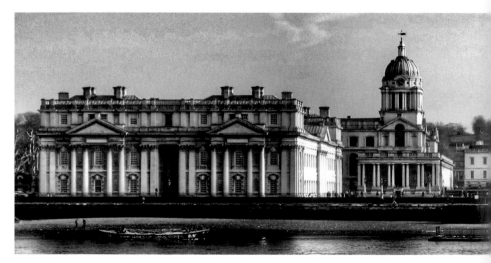

than creativity and innovation. The smartphone has made photography fun again. People are now using their smartphones as cameras and recording so much more of their lives than was viable with a traditional camera.

In this book we'll look at the power of your smartphone camera and how it can help you take some really great photos. We'll also look at the skills you can quickly develop that will make you into a great photographer. So whether you want to use your smartphone camera to develop your own photographic style or you are more conventional in your approach and merely want to exploit the camera in your iPhone, I hope you'll find some good advice and great ideas.

Just to close, I need to come clean on what smartphone cameras have been used though this book. Many images have been shot on iPhones of various vintages, purely because, as is the smartphone ethos, that's the one I carry with me everywhere. I hope you'll find, though, that this book is not really about hardware, it's about creating great images. So if you're a fan of smartphones from HTC, Sony, Samsung, Nokia – or whoever – you're very welcome.

Peter Cope

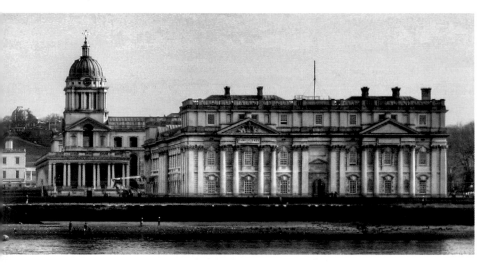

ALL ABOUT SMARTPHONE CAMERAS

Before we start to get creative, let's spend just a little time exploring what a potent tool that smartphone camera in our hands is.

The great thing about these cameras – and a smartphone in general – is that they are remarkably intuitive: you really can get shooting straight away. You don't need to plough through the manual (that's if you actually got one) to get going. But it's surprising how many people use a smartphone camera oblivious to some of the features on board, features that can make their photography even better.

Over the next few pages we'll look at features on your smartphone camera and how to get the best from them. Okay, so if you don't want to get technical (and I do inevitably have to use a slight bit of jargon) at this point don't worry – revisit this section later when you want to hone the brilliant creative skills you've developed.

By the way, have you ever wondered why smartphones rarely come with the compendious manuals that were commonplace once with almost any digital – or electrical – device? The manufacturers finally realized that few, if any, of us actually read them. They discovered that all we wanted was something to get going and so the traditional manual has given way to – at best – a brief quick-start guide.

GETTING TO KNOW YOUR SMARTPHONE CAMERA

What makes a smartphone camera? It's actually quite a bit more than you might think, a mix of high-technology components and software elements, all seamlessly integrated into the smartphone's overall functionality. Let's delve a little more deeply into what's on board.

THE CAMERA

The camera's optical elements are small – almost unnervingly so. For those used to conventional cameras and digital SLRs it's easy to be disparaging about a camera whose lens is almost laughably diminutive, but there's no need to be. That camera packs quite a punch.

Smartphones: The lenses on smartphones are surprisingly small, rarely more than a few millimetres across, but remarkably complex, comprising a number of optical elements, as shown by this exploded view of a Sony Xperia camera lens. (Courtesy Sony)

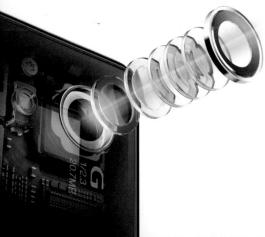

Alongside you'll also find a flash unit, designed to give you that extra burst of light when conditions call for it. I have to be honest and say that, rather like the modest flash guns supplied with some basic compact digital cameras, this can be a little underpowered for shooting good photos, but such are the limitations on space – and electrical power – within the smartphone body.

SOFTWARE

Unlike a conventional camera, there's no physical shutter release on a smartphone camera. Instead you need to run a software app – the camera app – to operate your camera. This app comes pre-installed on your smartphone and by selecting it your phone is instantly transformed into a camera, taking over the main display screen and providing you with all the photographic controls that you need to take photos.

Camera apps: As your photographic skills and needs expand you're likely to acquire additional camera apps that offer enhanced (or different) shooting controls.

The camera app is sufficient for most needs. It'll let you compose shots, focus on specific points, even allow you a degree of creative control. Your camera, though, is more powerful than these controls might allude to, and later, as your photographic skill and aspirations grow, you can download additional camera apps that give you additional functionality and control.

When you use your smartphone day to day as a camera you'll also find yourself regularly using another app, Photos. Use this to view your photos and, where necessary, perform minor edits. The Photos app will show your photos chronologically and on some devices give you calendar-based collections, complete with data on where the photos were taken if GPS (or equivalent) data was available at the time of shooting

If you're fully linked to the cloud you might find your images shared on other devices such as a laptop and tablet. Great for rapidly sharing photos and accessing them just about anywhere.

Photos editing: The editing features of Photos apps are modest but fine for simple modifications and corrections.

Cropping: When you haven't framed your shot properly, or want to concentrate on the main subject, you can use the crop tool to trim.

Colour effects: Change the basic colours in your shot to something brighter or take the colour away completely to produce a black and white shot.

QUICK EDITS

Use the Photos app too for simple edits on your photos. Don't expect anything too dramatic (as there are plenty of additional apps that cater for that) but it's perfect for quick fixes. Here's a quick rundown of what you're likely to find:

• Orientation – turn your photos though 90 degrees or even 180 degrees. Usually your smartphone detects whether you've shot holding your camera vertically or horizontally and will align the saved images accordingly, but if you're shooting at odd angles, use this to put things right.

• Auto enhance – adjusts the brightness, contrast and colour to give the best and brightest results. If you're familiar with image editing software on your computer it's much the same as the auto enhance or auto correct tools you'll find there.

• Colour effects – depending on your smartphone, you can quickly apply a special effect such as vibrant colour, black and white, pastel colours or toned.

• Red-eye removal – gets rid of that demonic red-eye look when using the on-camera flash, caused by flash light reflecting from the back of the subject's retina.

• Cropping – trim away superfluous parts of the image so the subject is more prominent.

TAKE TWO

Remember that smartphones also have a second camera, forward facing. Generally this is of lower resolution (and has an even smaller lens) than the main but is great for self portraits and those Skype or FaceTime video calls, where absolute quality is not so important.

KEEP IT CLEAN!

Conventional cameras – in general – offer protection for their delicate lenses, whether by retracting it into the body when not in use or relying on the user to snap on a lens cap. Camera phones' lenses are less fortunate and can be continually exposed. With their diminutive size an innocuous and barely visible fingerprint or smudge from a cake crumb (how many times have you put the phone down at your local coffee shop?) can ruin image quality.

Keep the lens clean by using a case when not in use or periodically wiping it with a soft, clean cloth.

FOCUS – AND TOUCH FOCUS

Sharpness is a prerequisite for a good photo. Okay, perhaps not always. Some creative images make use of blurring and lack of sharpness (we'll take a look at some examples later) but in most cases we will always want to ensure we have a sharp image or that the subject of our image, at least, is sharp.

FIXED FOCUS

No so long ago the cameras on phones featured fixed-focus lenses. Yes, 'featured', as they would boast about them in the specifications, lenses that would not focus at all! This is perhaps not as absurd as it sounds, as the compact nature of those camera phones' lens systems meant that they could keep most of a scene in good – if not critical – focus whilst focusing sharply on any objects around 3 metres from the lens. A good distance for shooting informal portraits.

These cameras could, in any case, only offer modest resolution, their colour rendition was not of the highest quality and the image quality they delivered was not the best, so a little softness in the focus was unlikely to be noticed. Especially as most would be viewed on the mediocre small displays commonplace on such phones.

TOUCH FOCUS

Now we have become a lot more discerning. We want our photos sharp, and our smartphones don't just let us view our photos on a larger, higher-resolution screen, they allow us to zoom in on details, so that any shortcomings become immediately visible.

Smartphone cameras today have pretty effective focusing systems. When you line up a shot and press the shutter release, the lens will focus nearly instantaneously and when the subject is in focus, your scene is recorded.

When I say 'subject', I mean what the camera believes to be the subject: whatever is in the central

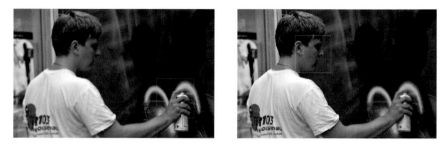

Touch focus: Touch focusing lets us easily determine where the camera should focus, overriding the camera's own setting. If you touch the wrong point, don't worry. You can change or refine the focus position as many times as you like and you'll see the results 'live' on your smartphone screen. Differences may be slight, but look how our attention is drawn respectively to the subject's face and hand.

part of the screen. It's logical to assume that what's in the centre of the frame is the subject but not always correct. You may want the camera to focus to one side or on a specific small item within the scene. Fortunately smartphone cameras make this simple: just touch the part of the scene you want to be in perfect focus and the camera will adjust accordingly. In many cases it will adjust the exposure too so that you can be sure your chosen feature will be perfectly sharp and perfectly exposed.

Once you've set your point of focus in this way, you can go ahead and take the shot – your settings will be locked in.

⬤ **TIP**

KEEP IT STEADY

Keeping the camera steady is also key to getting a sharp photo. That means holding your smartphone securely, best done with two hands. Taking one hand off to select focus points can make things a little unsteady, so practise your technique. See page 80 for more on keeping your camera steady.

When photographers talk about focus they also speak of depth of field. This bit of jargon is used to describe the amount of a scene that is in sharp focus. Whenever you focus on a subject, the in-focus zone will extend in front of and behind that object. A shallow depth of field means this zone is small and only the subject is really in sharp focus. With a deep depth of field, that zone extends considerably towards the camera and back beyond the subject.

Depth of field is used creatively, to isolate the main subject of a photo from its surroundings for example. Many smartphone cameras allow a limited amount of depth-of-field effects (as depth of field is determined by lens aperture size – the size of the opening in the lens) but often not to the same degree as traditional cameras. That's inevitable given the small-scale lenses of the cameras. But the smartphone camera people have thought of this and given us some apps that can enhance the depth of field.

Small-scale depth of field (below): You can add controllable depth of field – and give your images a fun 'tiny world' look – using tilt and shift apps (here Tilt+Shift in Google's Snapseed). In reality, this level of depth of field in a landscape would be impossible!

Enhancing depth of field (right): Typically for a smartphone camera the depth of field – amount of the shot in good focus – is broad, including those parts of the scenes close to the camera and more distant. That can mean a shot like this – of a ship figurehead collection – can appear a bit confused.

Shallow depth of field: Using an app (in this case Tadaa SLR) we can mark on the screen the area or subject we want in focus and the remaining elements will be gently blurred. Easy and surprisingly realistic.

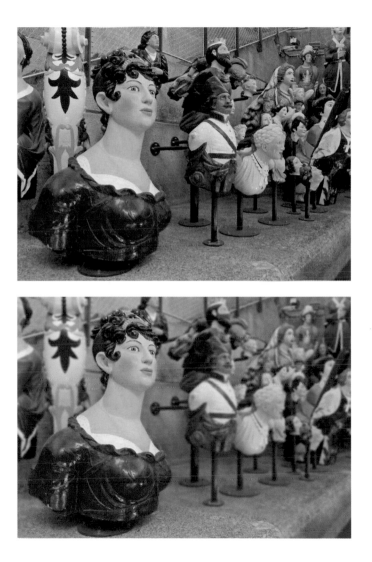

LETTING
THE LIGHT IN

When we take a photo – whether it's with the latest smartphone or something rescued from an emporium of Victoriana – the process is exactly the same. Once we've got the shot framed and ready to take, we press the shutter release button and the image is captured.

To get the shot perfect it needs – as we've just seen – to be in focus. It also needs to be correctly exposed. That means letting the right amount of light in. Too much and the photo will be all washed out; too little and it'll be dark and gloomy. To do so, your smartphone camera can vary the aperture (the size of opening that allows light through the lens) or the exposure time (the length of time that the lens's shutter opens to allow light in). Different combinations of shutter speed and aperture, though, can deliver different results.

Okay, we don't need to concentrate too much on any of the mechanical or practical details involved; let's see what varying these settings can do for our photos.

APERTURE

We touched on the lens aperture on the last couple of pages. It's the opening in the camera's lens that lets the light through. In simple cameras that's it. A single, fixed-size hole. However, in most cameras the size of this opening can be varied to allow in the right amount of light for the perfect exposure.

That's the technical bit. Aperture control (as we've also seen) has a creative angle, in that it affects depth of field: a small aperture gives the deepest, and the largest aperture the shallowest.

Controlling the aperture? That can depend on the smartphone. On some you'll find sliders or adjusters you can manipulate with your finger and see the results live. On others you may not have control using the standard camera supplied with the smartphone but check out your smartphone's app store for an enhanced camera app.

SHUTTER SPEED

You can make similar changes to shutter speeds – although perhaps not with the same degree of criticality as those familiar with conventional cameras will be used to.

• Select long exposure times to show motion in your shot.

• Select shorter exposures to capture everything pin sharp and freeze fast motion.

Whether you change aperture settings or shutter speeds, don't worry about the exposure – the corresponding values will be adjusted automatically.

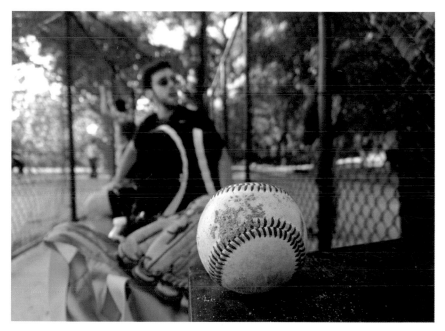

Wide apertures: In this stunning shot, taken with a Nokia Lumia 1020, attention is strongly focused on the baseball by selecting the widest possible aperture. (Courtesy Nokia)

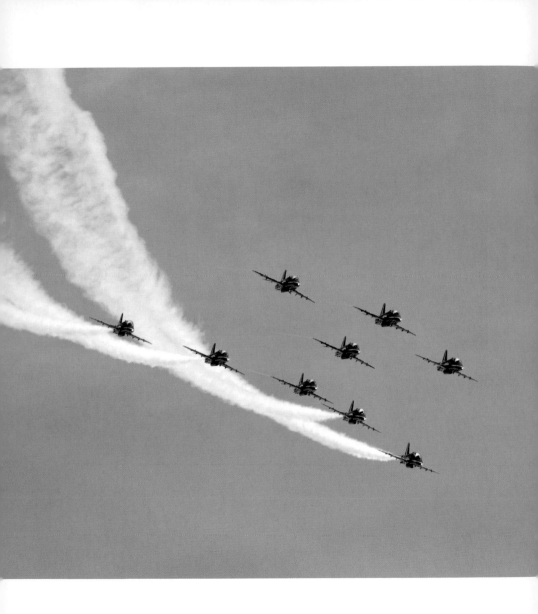

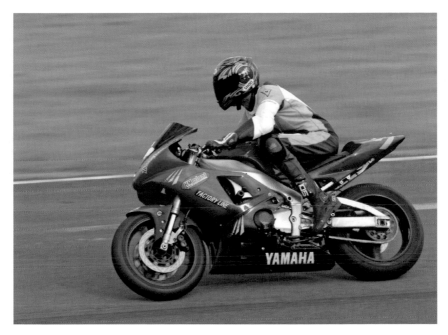

Shorter shutter speeds (left): Short shutter speeds can freeze the fastest motion.

Longer shutter speeds (above): Use longer shutter speeds and follow moving objects to get dramatic action shots.

THREE DEGREES OF FREEDOM

In fact, there's a third way in which exposure can be controlled. The camera can also vary the sensitivity of the little CCD sensor that records the image. Changes here don't change the image creatively but do affect image quality, as we'll discover later (see page 32, Image Quality).

ZOOMING IN

If there's one persistent mistake that marks out novice photographers, it's not getting close to the subject. Photos have so much more impact when subjects really fill the frame. Sometimes, though, you can't get close enough, physically or practically – shooting a timid pet or youngster, for example, or a distant landscape.

That's where the camera's zoom lens comes to the rescue. And it's so simple to use. Touch the screen with two fingers and draw them apart and you'll zoom in – steadily filling the screen with your subject. Pull your fingers together to zoom out to see the wider view.

If it's more convenient, you'll find a little slider bar on the screen that you can move with your finger to zoom in or out.

DIGITAL ZOOM

The convenience and flexibility of a zoom lens comes at a price. A small price for some, more significant for others. The built-in zoom of smartphone cameras is what's called a digital zoom. Rather than taking a shot of a magnified image, as you zoom in an increasingly small area of the camera's sensor is used to record the image.

The consequence is that when you've zoomed

in fully you're recording a much lower-resolution image than when zoomed out. Smartphone camera resolutions today are pretty good, even when zoomed, but this compromise might be limiting if you like to produce poster-sized prints from your best zoomed shots.

And, as with long shutter speeds, the more you zoom the more the camera will become susceptible to camera shake.

ZOOMING AND DEPTH OF FIELD

Depth-of-field effects tend to be enhanced the more you zoom in on your subject. Yes, this means you have to be more critical with your focusing, but it is great for separating subjects from messy backgrounds – something portrait photographers relish (see page 110, People).

Zooming: Using the zoom control lets you close in progressively on elements within the scene until they fill the frame.

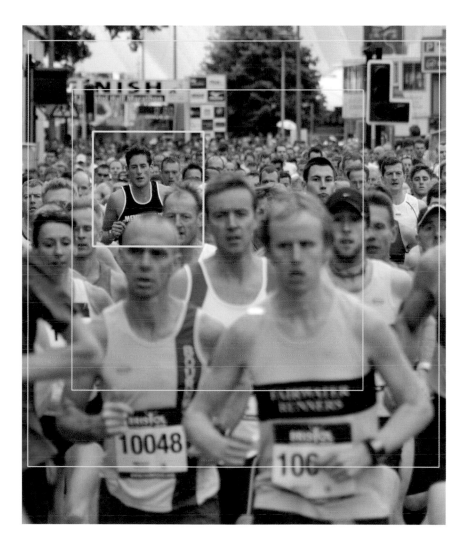

01 ALL ABOUT SMARTPHONE CAMERAS 25

Digital zoom: Zooming in to the face of this street performer lets us catch his determined expression but the resulting image can be softer due to the decreased resolution.

FLASH

Just about all smartphones – or rather their cameras – come with a flash. And it's tiny. In many cases smaller even than the lens of the camera. That begs the question, is it any use?

Those professional photographers who sneer at the size of the smartphone camera's lens can be heard howling their derision at the flash unit. But to do so is to miss the point. The flash on the smartphone is not designed to ape the sophisticated and powerful flash units that the pros consider *de rigueur*. They are built with obvious compromise: there is not the electrical power in the battery to offer something more significant (not without reducing battery life substantially) nor is there the space to add anything larger.

So what can this flash do?

FLASH MODES

First, you'll find there are several flash modes:

• Off – ensures the flash never fires. Select this if you want to use available light, or are somewhere where flash use would be frowned upon.

• On – fires the flash every time. Ensures you get the burst of flash light you want even if the camera determines that it's not needed.

• Auto – the camera will determine when flash is needed and when it's not and switch it on accordingly.

• Red-eye reduction – sends a burst of flash light before taking the shot to help avoid subject's eyes shining a bright red. (Personally I don't think this is particularly successful and prefer to remove red-eye using an appropriate app later.)

USING FLASH

I generally consider there are two occasions when using flash is desirable. The first is when there is too little light to get a good photo. That might be stating the obvious but it's surprising how many shots that are a bit dark can be rescued by using an exposure-modifying app. When things are a touch

Fill-in flash: The modest flash on smartphones is ideal for fill-in flash techniques: filling in the shadow areas in portraits. In the first shot here the bright overhead lighting casts unflattering shadows under the eyes and chin. A small burst of fill-in flash (setting the smartphone camera to flash always on) lifts these shadows to give a much more pleasing result.

The flash on smartphones can be a bit neutral in colour – even a touch cold. Use an app that can add a touch of warmth to the shot if this proves the case – especially if you're shooting portraits.

gloomier, though, the image is likely to get a bit grainy if corrected by an app, so adding some auxiliary light is essential.

The second is to help fill in deep shadows. When you're shooting in bright daylight and the sun is overhead – or even behind the subject – that subject will be normally be in shadow. A burst of flash (with the mode switched to 'On') will help lift those shadows.

FLASH APPS

Apps like Hipstamatic let you change the colour of the flash and the style of the flash – useful for giving more creative results than the standard flash gives.

MULTIPLE EXPOSURE

Multiple exposure is a term used to describe shooting two or more shots on the same image. Long ago, in the days of film cameras, the multiple-exposure technique involved not winding the film on between shots so the same frame of the film would be exposed twice.

Fast forward to the age of digital cameras and in-camera multi exposures became less common. Not because the technique fell out of favour but because it was simpler to combine images using image manipulation software once they were downloaded to the desktop. Smartphone cameras, though, have bucked this trend and many camera apps offer multiple-exposure features.

COMBINING IMAGES

Which shots you combine is entirely up to you. They could be near-identical ones, the the same view in each case but with just one small element changed or in a new position. You may choose instead to move the camera subtly between shots so that the whole scene appears out of registration. Or you may want to combine two entirely different scenes into one.

You don't need the two (or more) photos comprising the multiple exposure to be shot consecutively, as many of the camera apps will

Multiple exposures: Three separate exposures were combined to produce this shot. Between each I moved a modest distance forward. Using BlendCam ensured that the overall exposure was correct; often taking three separate shots can results in the combination becoming overexposed.

let you grab an image from your library. BlendCam (iOS) is a useful app of this type, letting you shoot multiple exposures and combining library images. Photo Blender (Android) allows similar blending of photo library shots.

ACTION SHOTS

The Action Shot mode (on certain Nokia Lumia cameras) lets you shoot multiple shots on a single frame that records motion. Someone walking across the frame, a car driving though or, as here, a skateboarder. Clearly for shots like this it's crucial that the smartphone is firmly mounted and doesn't move between the shots. There's another great example of this mode on page 52/53.

Action Shot: A great way of getting pictorial action photos, Action Shot is also a great way to analyse the way people move when, for example, running or taking a golf swing. (Courtesy Nokia)

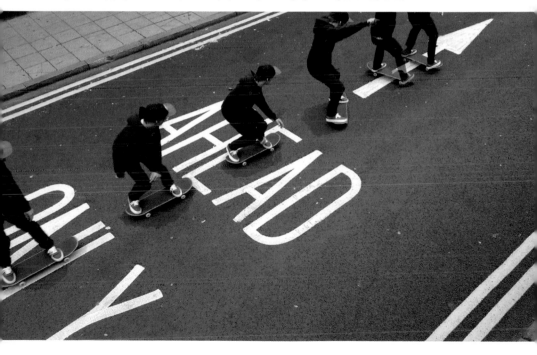

IMAGE QUALITY

To get the best images you need to start with a camera that can deliver the best image quality. When film was king, that often meant serious photographers were driven towards larger and larger cameras that used correspondingly larger film sizes. These would produce negatives or transparencies that could withstand a high degree of enlargement and, coupled with excellent lenses, result in top image quality.

Much the same happened when digital cameras arrived. Early models offered fairly low-resolution images but, almost from day one, the drive was on to offer greater and greater resolution. This was characterized by the marketing spiel that put the number of megapixels the camera offered at the top of the list of specifications.

Unfortunately, there is more to image quality than megapixels; more megapixels don't necessarily mean better photos. The only thing they can be guaranteed to offer is larger image files. Two other factors come into play when we explore image quality: the image sensor size and the software that processes the image.

IMAGE SENSORS

As you can imagine, the image sensor in a smartphone is tiny, just millimetres across. It's a marvel of miniaturization, around a quarter the size of the sensor you'll find in a basic point-and-shoot digital camera. But with small size

Sensor noise: small image sensors can generate electronic noise that particularly affects photos shot at low light levels and the dark shadow areas in daylight shots.

Sharpening: Image processing software can automatically sharpen your photos but the results don't always look authentic when seen close up.

comes problems. As you try and cram more and more pixels – the individual image sensing points – on to a sensor they become smaller and more closely packed.

The smaller size can, to a degree, compromise sensitivity but there's a greater problem: the close proximity can cause electronic noise to become more significant than would be the case with a larger sensor. Without getting too deep into the electronic theory this means that there's a greater likelihood of electronic noise in the images produced. That becomes particularly evident in images shot at lower light levels.

IMAGE PROCESSING SOFTWARE

The raw data from the image sensor needs to be processed to deliver an image. That's where the on-board image processing software comes in. This software is invoked seamlessly when you take a photo and works near-instantaneously.

As well as processing the data from the sensor, it can also, to a point, apply corrections. So it can identify that digital noise and, to a degree, suppress it. It can also – more controversially in the eyes of some photographers – apply other corrections. This can include sharpening effects. To overcome any slight softness in the image from the lens system the software can artificially sharpen the image to give a greater perception of sharpness. Why is it controversial? To many photographers you're adding something not in the original image: they would rather apply sharpening effects – if needed – later.

Overall, though, the image processing software is an important part of delivering your images.

WHY RESOLUTION IS IMPORTANT...

The key difference between a high-resolution image and a lower one is the amount you can enlarge it before the image breaks up into individual pixels. A high-resolution image means you can produce huge prints that keep their quality even when viewed close up.

A second benefit of a high-resolution image is that you can crop it (see page 162) for a better composition without unduly affecting the image quality.

High resolution: A high-resolution image will feature – if shot successfully – fine detail across the frame. It gives the scope to crop and still have an image with good resolution.

... AND WHY RESOLUTION ISN'T (ALWAYS) IMPORTANT

It's great to be able to produce poster-sized prints from your best images. But, ultimately, how many of these do you actually produce? What do you do with most of your images? If the answer is share them with friends on their smartphones, or email them, or even enjoy them on your computer, you don't necessarily need high-resolution images all the time.

Ironically, too, you'll inevitably use a range of apps to get creative with your images, which will deliver images that are often of lower resolution and deliberately so. Part of the effect is to inject a look that is coarse and grainy. Or soft and gentle.

Shop window: A bold, colourful image, but one that doesn't need a high-resolution image. The application of soft focus and blurring effects negates any shortcomings due to resolution.

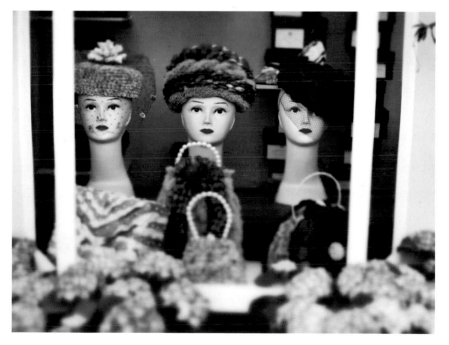

TABLETS
AND PHABLETS

Let's be honest. When Apple launched the iPad, kickstarting a new hardware market sector, it was really just an upscaled iPhone. Without the phone. And without a camera. The former was of little consequence as the early adopters would often be iPhone users too; the latter was addressed with the arrival of the iPad 2.

Since then the market for tablets (and their smaller phone-enabled siblings the phablets) has grown beyond even the manufacturers' bullish expectations. With specifications that are similar to smartphones it's not surprising then that many people now carry tablets and phablets with them just in the same way as the rest of us carry phones.

TABLET CAMERAS

So, tablets and phablets: how do they stack up as photographic devices? I have to admit, possibly because I come from a traditional photographic background, a degree of bemusement when I see someone standing by a famous landmark shooting photos with a full-sized iPad or Galaxy. To me it seems a touch cumbersome. Yet, as the users would attest, that huge screen is just fabulous to frame shots on. And, of course, they are right. They offer the sort of screen size a pro film photographer could only dream of.

And the camera itself? Early models of tablets

had cameras that were pretty much the equivalent of those on the previous generation of smartphones; cameras, it can only be presumed, were considered to be lower down the feature list demanded by tablet purchasers. Now, though, they have caught up and are pretty much on a par with those you'll find on a corresponding smartphone.

Any other benefits? The size, rather than being a handicap, is a virtue when it comes to holding securely. No need for the dainty grip so often

The big view: The screen of a tablet – even a midi-sized model – gives you a larger space to help you compose your shots.

Subtle manipulation: The large screen of a tablet gives you greater scope to perform fine, detailed manipulations, such as selectively blurring the background in this shot.

seen when shooting with a smartphone: with a tablet you can really get a firm, stable grip which means sharper photos.

A PORTABLE WORKSTATION

So, as a camera, a tablet can hold its (rather large) head high. What about manipulating the images you've shot? Just about all the apps and tools that you'll find on a smartphone will also be there on a tablet. So you can manipulate your images in just the same way. Well, not quite. Now that large form means you've a much larger screen to play with. So for apps that require subtle use of your fingers – such as the painterly ones – there's less zooming in and out and the whole experience is much more fun. And for all other apps there's less need to squint at the modest real estate of a smartphone screen.

SHARING YOUR PHOTOS BETWEEN DEVICES

Don't forget that many smartphones and tablets – and computers for that matter – can sync so that images shot with your smartphone can, for example, then be edited on your tablet – see page 220 for more about sharing.

THE VERDICT

So, is a tablet – or phablet – a good bet for photography? Judge for yourself:

PROS

- Brilliant, large viewing screen
- Easy to hold steady
- Great for detailed editing of images from the image library

CONS

- Size – not quite 'go anywhere' devices
- Not all apps for smartphones are compatible
- Doesn't necessarily have all the secondary (non-photographic) features of a smartphone

VIDEO AND MOVIE-SHOOTING FEATURES

Okay, so this is a book about smartphone photography. But it would be churlish not to at least mention phones' video abilities, as even the most committed photographer will occasionally discover an opportunity that demands shooting at least a few seconds of video footage.

The good news is that if you've got to grips with your smartphone's camera mode much of what you have learned can be applied to the video mode. The controls are generally the same and what you can do when either mode is selected is much the same. The main difference, perhaps obviously, is that when you press the shutter release button (as we would refer to it in camera mode) you are merely starting your video recording. You'll need to press it again to stop.

SWITCHING TO VIDEO MODE

Switching between photo and video modes is generally pretty obvious and simple – often a swipe of the finger. In fact, many people complain that it's almost too easy to switch and it can often be done accidentally. Almost all of us have tried to take a spectacular photo only to find – some time later – that we've actually recorded a video and only now, when coming to take the next shot, realize that we're actually just ending the recording.

VIDEO MODE VS PHOTO MODE

With the obvious exception that you are recording moving images, the operation of your camera in video and photo modes is pretty similar, but with some important operational differences:

• Resolution: the resolution of recorded video is lower than that from the same device when set in camera mode but still high – you can often expect HD (high definition) quality.

• Focus: if you are shooting subjects moving towards or away from the camera, check your smartphone's video mode allows focusing during shooting. Many 'freeze' the focus when you first press the shutter release.

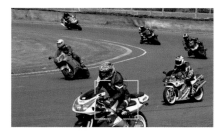

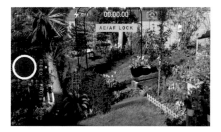

Keeping focus: Some smartphone cameras don't focus continuously in video mode. If you have subjects moving towards the camera, prefocus the camera to the foreground so that the subjects will be sharpest when closest to the camera.

Locking exposure: You can lock the exposure (and the focus where focus may otherwise be varied) by engaging the AE/AF (auto exposure/autofocus) lock. Locking the exposure can help avoid the brightness changes in a video clip that can be uncomfortable to view.

• AE/AF lock: conversely, some cameras do allow focusing during shooting. This is not always a benefit as the focusing system can 'hunt' for best focus continually. You can lock the focusing to avoid it doing so; you can also lock the exposure settings so that the scene brightness doesn't constantly change as the subjects in the frame move.

• Zoom: you may not be able to use the zoom feature when shooting video. As described on page 224 (where we discuss movie production) zooming during a video shot is regarded as bad practice in any case, so this is not necessarily a drawback.

• Effects and apps: the effects and apps you can apply to photos – either when shooting or later – are mostly exclusive to stills photography. There are, however, a whole slew of effects apps – and editing apps – exclusive to the video mode and video clips.

HOLDING YOUR SMARTPHONE

It's crucial to hold your smartphone firmly when shooting video, just as it is when recording still images, but there's even more scope for unsteadiness. Watch out too that the action of pressing the shutter release to start and finish the recording doesn't introduce a brief visual tremble at each end of the recording.

SMARTPHONE TOOLS

By now you'll have gathered that your smartphone is a pretty good camera. In fact, it can be really good. It can certainly hold its head up high in the company of many conventional digital cameras. But your smartphone is not just a camera, it can do a lot more besides. For the photographer some of these other functions can be a useful adjunct to their photography. Take GPS for example.

PINPOINTING YOUR PHOTO LOCATIONS

It's amazing, really, how much you can pack into the small form factor of a smartphone. Just as a camera can be miniaturized and still pack a punch, so the hardware and software essential to locational services – such as the ubiquitous GPS or Global Positioning System – can be discretely hidden within.

In fact most phones use an even cleverer hybrid location system that combines GPS with a system which calculates position relative to the phone masts that you link to for your calls and data. This gives better accuracy, particularly in the heart of the city where GPS data accuracy can sometimes be compromised by tall buildings.

Whatever the method, location services are useful not only to guide you to your photo-shoot locations but also for geotagging: attaching – or

I was here: Computer apps like iPhoto will display where you shot photos conveniently on a scalable map. Zoom in for precise shooting locations.

tagging – your images with details of the place they were shot. This makes it easy to find out later exactly where you shot your photos. Ideal

if you're on a long trek and find a wonderful shooting location that you want to share or revisit at some time in the future.

Geotagging data is automatically downloaded to a computer with your images. It's included in the data – called metadata – that is saved every time you shoot an image and with the right software you can view this, either as geographic coordinates or, more usually, on a map. Some smartphones too can display this information, or use the data to group your photos together by location.

HIDING YOUR PHOTO LOCATIONS

Geotagging data is always saved automatically. It's also extremely accurate – defining location with house-number accuracy. But this also means every time you share an image, emailing to a friend or posting it online, that data is also shared. You may not, however, want to share the data? What if you want to share photos of a wonderful location but don't want to broadcast to the world where it is? Or, thinking security, what if you've taken some great photos at home and don't want to reveal where you live?

Well, if you don't want to share, or if you want to change incorrectly stored tag data (it happens sometimes), you can do so using apps such as Pixelgarde (iOS, Android). You can quickly delete or update the info.

HDR – HIGH DYNAMIC RANGE

For many smartphone camera users the HDR feature is one whose results are well understood but principle of operation is less so. Select HDR when shooting and photos seem, well, brighter and perkier. So what is it all about?

Our eyes are pretty remarkable in what they can see. On a bright sunny day they can accommodate details in dazzlingly bright clouds one moment and features in deep shadows the next. Unfortunately, despite much research and development, the imaging chips of cameras – of all types – can't accommodate such a wide range of brightnesses (or dynamic range if we use the right jargon) in a single shot.

Shoot a photo where those fluffy clouds are well exposed and any shadow areas will be black and featureless. Shoot for the shadows and the sky will be white and featureless. Expose for part of the scene between the two and you'll get a result that retains at least a little of the details in all areas. Good, but not perfect.

SHOOTING WITH HDR

When we shoot with HDR enabled the smartphone will take three photos in very quick succession – one exposed for the brightest parts, one for the dimmest, and finally one for the average brightness areas. It all happens very fast so there's no need to be unduly worried about camera movement between shots.

Now comes the interesting bit. The computer in your phone looks closely at the three images and determines which parts of each are correctly exposed. It them combines those together to create one that is perfectly exposed in all areas.

Everglades (opposite): A rather prosaic shot of homes along the Everglades in Florida becomes somewhat more brooding when given the HDR treatment, as if some serious storms are approaching.

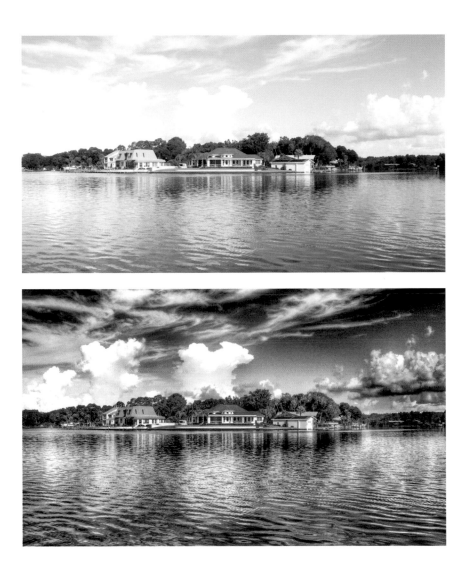

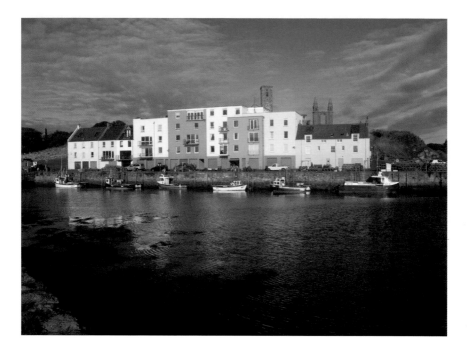

HDR vs HDR APPS

The HDR technique has become so popular there are many apps that now offer HDR effects on already-shot photos. You might ask how can you apply HDR to a single existing image when it actually takes three to compile one? To be blunt, you can't. The HDR app effect is not true HDR but it does make a remarkably good approximation, and is great for transforming images that might be slightly compromised by a restricted dynamic range.

How do these apps compare with true in-camera HDR? The results are often more extreme and have more impact. They may not be strictly accurate photographically but wow do you get some great images! The good thing is, if you do apply an HDR app and find the effect too extreme, you can use the effect sliders to reduce the level to something that gives a better pictorial effect without becoming garish.

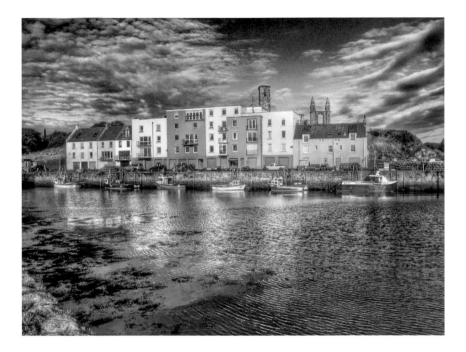

St Andrews harbour: Seen in the early morning
light, the harbour at the Scottish golfing mecca
of St Andrews is pleasant enough (left), but by
applying an HDR app (there are many available for
both iOS and Android) not only do we see what's
lurking in the shadow areas but we get much more
texture – perhaps a little too much – throughout
the image (right).

ADVANTAGE SMARTPHONE!

A seasoned photographer? Have some reservations about the effectiveness of using a smartphone camera? Put aside those concerns now. Here are some of the opportunities and situations where using a smartphone camera doesn't merely put you on par with a conventional camera but gives you a distinct advantage.

DISCRETION

Walk into a major museum, concert venue or sporting venue with a pro-looking camera and, if you're not prevented from entering, you'll be viewed suspiciously. Head in with a smartphone and no one is going to look twice. In fact, at some places you'll look out of place not carrying a smartphone.

One caveat – though you can take a smartphone just about anywhere, that doesn't mean you can use it anywhere: there may still be restrictions on camera use. That may be for practical reasons – the hosts don't want other visitors annoyed by those composing and shooting photos – or copyright reasons: there are legal restrictions on things you might shoot. Be mindful of these unless you want to feel a firm hand on your shoulder!

INSTANTANEOUS SHARING

Think of those life-changing events. The birth of a child, for example. With your smartphone you don't just announce the birth in a text, you can send a photo too.

EVERYTHING YOU NEED IS ON BOARD

I recall often heading off to shoot photos in unfamiliar locations. I'd pack my camera bag with all the usual photo kit but have to make

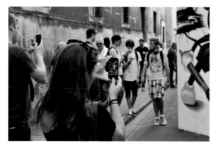

Smartphones are everywhere: You don't need to feel self-conscious about using one.

room too for maps, guide books, a compass, tide tables and plenty more. All in all, a significant payload. Now, the smartphone provides not only a map but my precise location, every guidebook I might want and the latest weather forecast. My back is forever grateful.

IT'S THE ALL-IN-ONE PHOTO STUDIO

You don't just shoot photos on your smartphone, you can edit them there too.

QUALITY

Phone cameras have made great strides since their introduction and can deliver quality images. No apologies or compromises are needed.

YOUR CAMERA IS ALSO A PHONE

Need I mention this one? Your camera is still a phone so you can keep in touch wherever you are. And there's no need to carry around separate devices.

... AND FINALLY

Your smartphone is valuable. To you and to anyone that might want to relieve you of it. It's all too easy to get seduced by exciting shooting locations but do always be mindful of your own safety.

Edit on the fly: No need to wait to get home and download your images, you can do some quick edits on location.

KNOW
YOUR APPS

They're what set your smartphone apart from other devices and particularly other phones. Apps transform what is notionally a communications device into something quite different. And for the photographer, there's quite a range of useful – and interesting – apps available.

Let's explore some of the different types. For each of the categories below I've listed some popular corresponding apps. It's not an exhaustive list – and you may well have found your own favourites already.

CAMERA APPS

Your smartphone will come with a camera app that's perfect for most occasions. But there will be times when you need that little bit more control or you'd like the camera to help you deliver results that, straight out of the box, it can't. You'll find camera apps that let you shoot slow exposures, double exposures, include a built-in spirit level and more.

There's also a wide selection of cameras that are designed to transform images when shooting. It may be my personal slant, but I'm a bit cautious about these. Yes, you may get some interesting, fun or wacky results, but you're stuck with them. Shoot a straight photo though and you can apply any one of hundreds – perhaps thousands – of effects afterwards. If

Image editing suites: For all your basic – and a few more esoteric – image manipulations, it's a good idea to get to grips with at least one image editing suite app.

one doesn't work, no matter. You can go back to the original image and try something else. Something you can't do if the effect is indelibly committed to your image.

We like:

- ProCamera (iOS)
- CameraPro (Android)
- Retro Camera (iOS and Android)

IMAGE EDITING SUITES

Once you've got some great shots on your phone, you'll want to do something with them. Correct a wonky horizon or pep up muted colours, perhaps. That's where image editing suite apps come in: a collection of often-used tools bundled conveniently together so that, in a few keystrokes, you can get your images looking better. And, perhaps, for good measure, letting you apply a few fun effects too.

We like:

- Adobe Photoshop Express (iOS and Android)
- Google+ Snapseed (iOS, Android, Chrome Browser)
- Aviary Photo Editor (OS and Android)

SPECIALIST IMAGE EDITORS

Sometimes you'll have a more specific image modification in mind. Suites are great for quick fixes and manipulations, but if you want a bit more subtlety or want to exercise a little more

Painting apps: Painting apps let you apply brush-stroke-type effects.

Art effect apps: Release your inner artist by manipulating your images in an art effect app such as this that produces posterized results.

control, go for a more specialized app. You'll find a huge range and you're almost guaranteed there will be at least one app that does exactly what you want, whether it's creating the illusion of an old retro camera photo, producing subtle black and white effects or even helping you turn a photo into an artwork.

We like:

- Mobile Monet (iOS and Android) – hand-drawn watercolour effects

- Soft Focus (iOS and Android) – dreamy soft-focus effects

- Dash of Color (iOS and Android) – localized colour effects

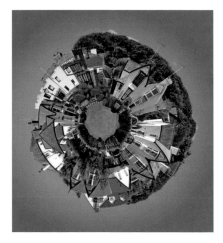

Tiny planet: Some of the more extreme image manipulators, but ones that can deliver intriguing effects if done right, are the tiny planet apps.

- Old Photo PRO (iOS), Old Photo Effects (Android) – gives contemporary images an aged appearance

- MySketch Editor (iOS) – sketch art effects

EXTREME IMAGE MANIPULATORS

What if your image manipulation intentions are less sober and more radical? You'll be pleased to know there are plenty of apps that can create fantastic – or powerful – images from your photos too. You can turn landscapes into tiny worlds or shoot 3D images, 360-degree panoramas and immersive environments. And for good measure turn an everyday image into something psychedelic.

We like:

- Scene (iOS) – three-dimensional imaging

- Camera360 Ultimate (Android) – panorama creation, manipulation and sharing

- Microsoft Photosynth (iOS) – immersive environments

- Tiny Planets (iOS), Tiny Planet FX Pro (Android) – tiny planet effects

A VIRTUAL KITBAG

You needn't limit your smartphone to being a camera to become a better photographer. As well as being a collection of photographic shooting and processing tools, it can also be a virtual photographer's kitbag, packed with useful information on shooting locations, a diary of your photographic adventures and a

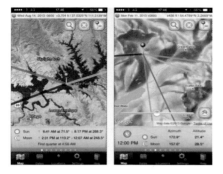

Photographer's Ephermeris: Apps such as this are great for getting the best from your photo mission.

GETTING SOCIAL

Though this is ostensibly a book about photography, most of us enjoy sharing photos too. So it should come as no surprise to find there are plenty of sharing apps out there too – we'll look at these in more detail in Chapter 8.

Social apps: You've plenty of opportunities to share your photos directly with friends and via social media.

Multi exposure action shot (overleaf): Action shots like this make use of multiple exposure techniques. Good timing is essential to get excellent results. (Courtesy Nokia)

shelf of photographic reference books.

I particularly like – dare I say love – the Photographer's Ephemeris (iOS and Android) which is packed full of useful info on sunrise times, direction of light, maps (including terrain) and a great deal more that together mean you can plan a photo expedition in detail before leaving home.

We like:

- TPE: The Photographer's Ephemeris (iOS and Android)
- Spirit Level (included with many smart phones) for perfectly level shots
- The Photographer's Assistant (iOS) – keeping track of your photo assignments
- Photographer Field Tools (Android) – advice and tips on shooting opportunities

INFORMATION AND INSPIRATION

Lastly your smartphone can also be an eBook reader – and eMag reader – letting you gain tips and inspiration from the latest smartphone photographers and using the latest apps.

We like:

- Fltr – calls itself the first online magazine for smartphone photographers, is optimized for reading on a smartphone
- Snap Magazine – one for the Hipstamatic devotee

2 HOW TO BE A BRILLIANT PHOTOGRAPHER – WITH YOUR PHONE

There's an often-repeated tale amongst photographers – and usually by the grumpier ones – that says how offended *he* was (the photographer telling this tale is invariably male) when, out shooting a wedding with his top-of-the-range SLR kit, he was told by a guest, 'You've got a really expensive camera so you must be a really good photographer!' There was the perception from the guest that it's the camera that makes the picture, technically and creatively, not the photographer. The more you pay, the better the results will be.

The explosion of creative and dynamic photography squarely down to the smartphone camera blows that argument apart. So what makes a brilliant photographer if it's not great kit? In this chapter we'll attempt an answer by exploring some of the techniques and a few tricks that can set you on the road to stunning images.

UNDERSTANDING WHAT MAKES A GREAT PHOTO

The answer to this question can be as elusive as 'What makes a great photographer?' but here are the top five I'd offer. Certainly not definitive, but the list includes those many photographers might suggest. Even the ones with expensive kit!

1. TECHNICAL PROWESS

By which I mean the technical aspects meet your expectations. So, if the photo is underexposed or blurred and you meant it to be, then that's fine. If you meant to shoot a pin-sharp image and it's blurred through a little hand shaking or vibration then it fails to make it.

2. ATTENTION-GRABBING COMPOSITION

You've got all the important parts in the image sitting together well. Whether or not you've followed some basic rules of composition – more of which over the page – the look of the image grabs your attention and that of anyone lucky enough to share it.

3. UNUSUAL AND QUIRKY

Some photos are simple records. They look like so many hundreds – or thousands – taken before. So try and look for an unusual angle or some quirky element that will lift your shot above the ordinary.

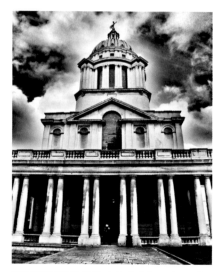

Imposing building: An imposing building, enhanced by the use of some effects apps? Or an overworked image of a building shot from a poor position? We can interpret images in different ways. Although there are some rules to guide us as to what is generally considered 'good' and 'bad' it's often down to the photographer as to what he or she sees as a good image.

4. EMOTIVE

Like music, some photos inspire us, others just wash over. A good photo may pose questions. About the content. Or why it was shot. The more emotive your shots, the more you'll value them and others will want to explore them.

5. SHOOT FOR YOURSELF

Shoot photos you like, the way you like. If you like how your photos look but few others do, don't compromise.

This is not a checklist – there's no need to tick off each before declaring an image 'good' and in time you'll probably come up with your own list. Meantime, like many of the guidelines we'll be looking at shortly, they are good to acknowledge, if only at the back of your mind.

Urban decay: What does this photo say to you? A sad reflection on urban decay? A mysterious, threatening environment? Brilliant street art? What we each see can be distinctly different.

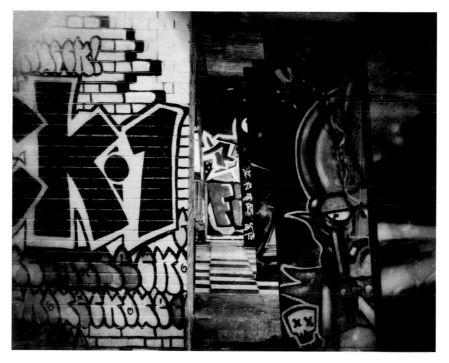

COMPOSITION

Serious photographers use many rules when crafting their images. These rules govern the best setting of shutter speed, the best aperture to use, and the best angle to shoot from. But when it comes to rules, more has been written about the rules of composition than just about anything else.

THE CLASSICAL RULES

Many of the classical rules of composition can be traced back to the way artists constructed their works of art using lines, ratios and proportions that were the most pleasing to the eye. They provided balance and structure. Arguably easier to do if painting on a blank canvas compared to photographing an existing scene.

Rules, though, can be constraining and can make us think too formally; they can kill spontaneity. But there's no doubt that an awareness of these rules can make you think creatively and ultimately improve your photos. And never be afraid to deliberately ignore any rule if you think it will deliver a better photo.

GETTING STARTED IN COMPOSITION

So how do we get started in understanding composition? The place to start is the screen on

Rule of Thirds: Perhaps the most well known and, arguably overused (because it's a simple way to get a good composition) compositional tool is the Rule of Thirds. See page 60.

your smartphone camera. You need to look at it perhaps a little more closely before pressing the shutter release than you normally would.

Of course, you always check the screen before shooting, but are you really looking at what is happening there? Have you checked that your subject is looking its (or his/her) best? Is it best placed in the scene? Have you checked the background? Too many potentially great photos have been ruined because a tree (or a telegraph pole, building or downpipe) appear to be sprouting from the subject's head.

Is there something else in the shot that might prove a distraction? An area of bold colour (reds are the most prominent) or a bit of clutter? If there is, it will compete with your subject for attention. Something as innocuous as a bit of street furniture – a direction sign for example – is enough to attract unwanted interest.

Conversely, do you need to include something more in your scene? A distant view may well benefit from something being placed, compositionally, in the foreground to balance the faraway subject and help lead the eye into the scene.

Over the next few pages we'll look at some of the rules of composition – and a few more creative concepts – and how they can affect our approach to taking a photo.

Simple backgrounds: A simple compositional tool to give prominence to your subject, or subjects: a simple background. See page 88.

Zoom in: Zooming in on an otherwise complex scene lets us focus on details that can take on a bold graphic look. Sometimes getting a good photo is more about what you leave out than leave in. See page 84.

RULE OF THIRDS

I'm not one to follow too many rules in photography. Not that this makes me particularly maverick in my approach, rather it is that obeying formal rules can lead to photos that are too prescribed, too predictable and can lack spontaneity. But this is one rule I do recommend, even if you use it sparingly.

A CLASSICAL APPROACH

So what's it all about? Originating in classical art, think of your image divided into three both horizontally and vertically. For the most powerful results you compose your shot with important elements along one of the dividing lines. Similarly, the subject should be placed at the intersection of horizontal and vertical dividers.

Screen grid: It's useful for keeping your shots straight and level too, but the screen grid is perfect for composing a shot that follows the Rule of Thirds.

Actually it's one of those rules that's easier to see in action than it is to describe. In fact most smartphone cameras feature grid lines that can be displayed on the screen to help you align objects accordingly.

Here's a couple more tips about getting the best from the Rule of Thirds:

- When shooting portraits you'll get the strongest compositions if your subject's face – or eyes, if closer up – are on one of the intersections of dividers.

- Try balancing the subjects: placing one subject at (say) the top left intersection of dividers and another, complementary object at the lower right.

Just remember: don't be afraid of breaking the rule deliberately and obviously if the result will be a more powerful image. Be guided by rules, not dominated by them.

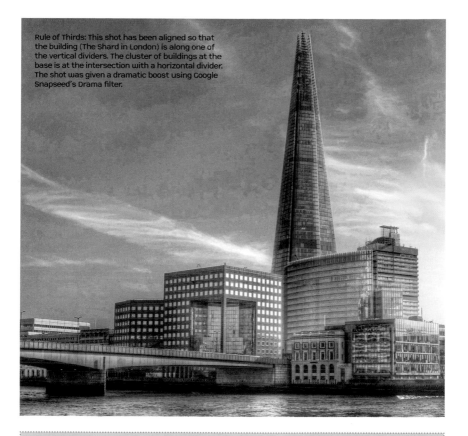

Rule of Thirds: This shot has been aligned so that the building (The Shard in London) is along one of the vertical dividers. The cluster of buildings at the base is at the intersection with a horizontal divider. The shot was given a dramatic boost using Google Snapseed's Drama filter.

◯ TIP

TRIM YOUR IMAGES

It's not a cheat, but you can trim your images (using the crop tool in your camera or photo display apps) so they better fit the Rule of Thirds criteria.

SYMMETRICAL COMPOSITIONS

The Rule of Thirds is a great starting point for conceiving a scene, but some bold subjects can almost cry out for an alternative approach. Those with a strong degree of symmetry are a good case. Such compositions can be really powerful when you have a strong graphic subject.

The line of symmetry can run vertically (as with the examples here) or horizontally. A scene, landscape or townscape reflected in a clear still lake can produce a bold composition with the horizon – the line of symmetry – dividing the frame in two.

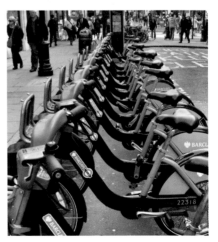

Symmetry: Symmetrical compositions needn't be as precise and graphic as in the case of this Floridian Hotel. It can be more approximate. Either way it does require an obvious subject or subjects.

VARIATION ON A THEME: CIRCULAR AND SPIRAL SYMMETRY

Circular objects can also have a strong degree of symmetry that produces a bold image. This dome, for example. To give the shot even more impact the image has been trimmed so that it is square and very tightly framed on the subject.

I'm not sure whether it's strictly circularly symmetric but I find spiral patterns really powerful. If you're wondering where to find them, think of snail shells (good practice for shooting really close up), fossils in rocks and, my favourite of all, spiral staircases.

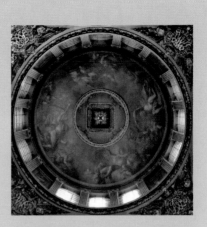

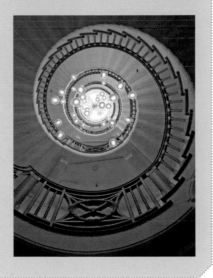

Dome (above): Cropping this painted dome emphasizes its circular symmetry.

Heal's (below): The London department store boasts this magnificent staircase. To get the best shot of any spiral staircase, you need to position yourself at the precise centre of the spiral. Rather than lie down uncomfortably, set your smartphone camera's self-time and place it flat on the floor.

FACE-ON

Stand facing your scene (or subject) and shoot. That's – almost – all there is to face-on shots.

Perhaps it's the heritage of grim, flat-looking portraits used for passports or the equally grim determination by photographers to 'always find a new angle' but the face-on composition has been relegated to the photo compositional sidelines for too long.

With face-on shots it's less important to give your shots depth than it is to provide an intriguing blend (or perhaps contrast) of colours, textures or shapes.

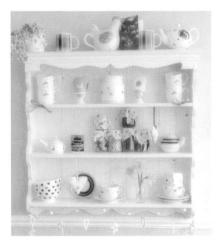

> ## ◉ TIP
> ### FACE-ON PORTRAITS
> The face-on approach can also be used for portraits but is generally unflattering. Capitalize on this by using app filters that enhance the severe look. Cross-processing filters work particularly well.

Dresser display: Slightly contrived, perhaps, but this dresser display uses a mix of colour and form to create an image that's both fun and interesting – our eyes spend time exploring. The application of a soft-focus effect (using a soft-focus app) helps soften the edges and gives the shot a dreamy, ethereal feel.

Ice cream trailer: It's the mixture of textures here that creates interest. An HDR app has been used subtly to even out some of the high-contrasting areas.

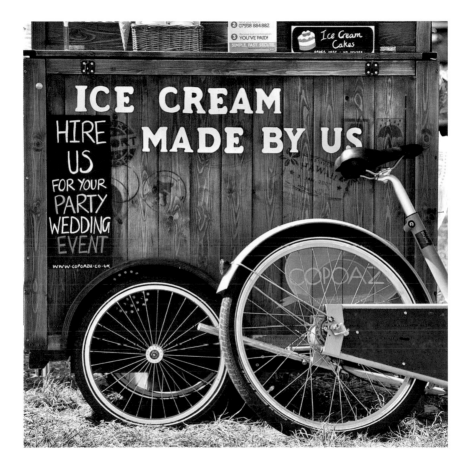

FINDING A
NEW ANGLE

It's surprising how many photos are taken from the same angle: eye level, around 1.5 metres from the ground. Nothing wrong with this, of course, but it does mean that your photos can get a bit samey – the same perspective and the same angle on your subjects.

There are times, though, that shooting from eye level can have detrimental effects: shooting a child, for example, from adult eye level is unflattering and can leave the child looking vulnerable – rarely the intention.

GET DOWN LOW

Look instead, for new angles and positions to shoot from. That child? Crouch down and shoot them – and their world – from their level. Or go that bit further, and shoot the subject from ground level. This produces some really great child portraits, as from this angle they look more confident.

The same technique can be used on other subjects – such as shooting tall buildings from below with the smartphone pointing upwards. Getting in low and close can exaggerate the scale and size of subjects.

THE HIGH GROUND

You'll get quite different effects if you stand on high – or hold your smartphone over your head, looking down on your subject. A high angle can also give you – or rather your photos – a sense of superiority that can make subjects look subordinate or submissive so use with care.

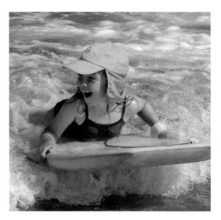

Crouching shots: Shooting children from their eye level leads to more engaging shots, whether in formal portraits or candid shots.

Young puppy: Don't be afraid to get down really low on the ground. If you don't fancy lying face down, then just get your camera down low as you crouch behind it – you should still be able to compose your shot and release the shutter. In this shot a burst of fill-in flash (see page 28) has been fired to overcome the shadow areas in the subject.

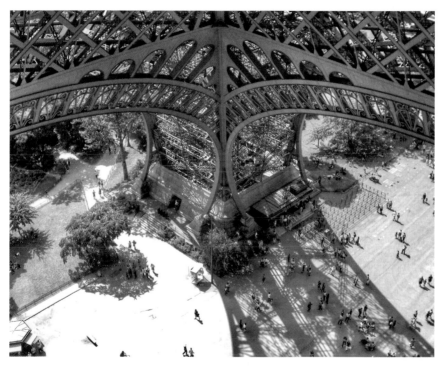

Eiffel Tower: The Eiffel Tower has been shot so many times from so many directions, almost every photo looks like a cliché. Here's a different view, shot from within, looking down to the ground. It's also been framed symmetrically for added impact. A 30% HDR effect has been applied to reduce the contrast between the bright ground and the shaded metalwork.

ACROSS THE DIAGONAL

If you want to break the Rule of Thirds with a vengeance – and get some really powerful shots – have a go at shooting across the diagonal. It's also a great way to emphasize height or depth.

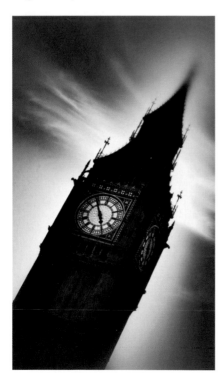

The rule here is quite simple: you place any bold lines in your shot across a diagonal. What do I mean by lines? It could be a building, a roadway, even (as opposite) fencing. You could even throw away all the rules and try putting the horizon across the diagonal – something that can work very well if you've some bold foreground interest.

What's the rationale of diagonal compositions? In some cases it's practical. In tight spaces it can be hard to record all of a building, say, even when the camera's lens is zoomed out fully. You'll find the height of buildings can appear exaggerated and more imposing.

In other cases they can be used to exaggerate the depth of the scene; your eye will be drawn through the scene to seek out what's going on in the most distant corner – very literally.

Big Ben: The conventional straight-up shot here would have looked pretty lacklustre but by shooting along the diagonal the result is much more impressive and emphasizes the height of the building. Here an HDR effect has been applied along with a blur effect.

● TIP

BE BOLD

Do make sure you place your important objects across the full diagonal, no half measures. Otherwise it can look as if you've just not held the camera steady!

BE SPARING

The diagonal composition is bold and very obvious, so don't use it too often as shots can become rather 'samey'.

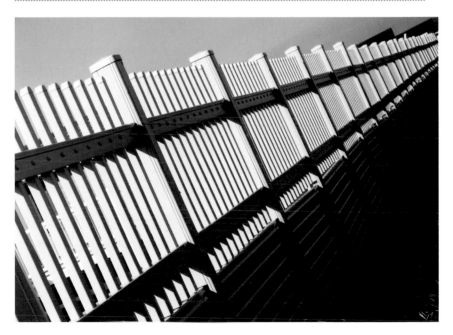

Picket fence: This shot of a picket fence receding into the distance makes full use of the diagonal. The PhotoToaster (iOS and Android) Hipster filter adds just a touch of surreal colour to the otherwise bland grey fence.

FRAMING
OUR PHOTOS

I'm not talking here about ways of displaying printed pictures around the home – or, if your aspirations are greater, in a gallery. Rather it's the compositional technique of using foreground objects to lead the eye to the main subject of the photo.

Framing can be literal – showing a scene through a window frame for example – or a little more subtle. Either way, there are several ways in which the framing technique can enhance a shot:

• Giving an increased sense of depth. Rather than a scene – perhaps a landscape – that is perceived as rather flat, we can increase the apparent sense of depth as we look though more nearby layers.

• It's a way of leading the eye. The frame draws your eye straight to that subject and iit becomes immediately apparent what is the key subject of your shot.

• Added context. The type of frame you employ can help reinforce the setting of your shot.

Moghul temple: The gateway into this Moghul temple provides a somewhat literal interpretation of a framed shot. It adds obvious depth, particularly when combined with the lead-in line of the path to the temple.

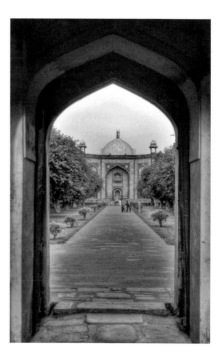

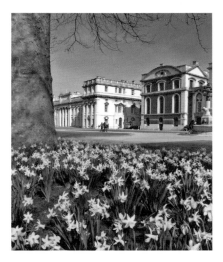

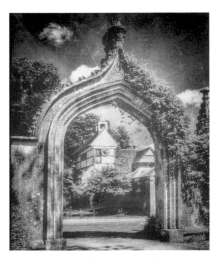

Spring landscape: A frame need not be so literal as in the case of the Mughal temple. Here a tree and some early spring daffodils provide the framing that draws the eye to the classic buildings beyond.

Gateway: Another traditional – though pictorial – approach to framing. The gateway here, which is obviously part of the scene, leads you through to the building beyond and provides the context to the scene.

USING BLURRED ELEMENTS AS A FRAME

You can enhance the depth in smaller-scale scenes by using an app to blur the framing elements. When you look at such a scene, as here, your eyes naturally flow over the blurred parts, which we instantly perceive to be closer, towards the sharply defined subject.

Tulips: By selectively defocusing peripheral parts of the scene the result is similar to using a wide aperture lens and it is clear what is meant to be the subject. If the whole scene were in sharp, or near-sharp, focus the result would be a hotchpotch of colour and pattern.

TIMING

Timing is critical in photography. Okay, so if landscapes are your forte it may be less so. But elsewhere, getting the timing right is crucial. Pro photographers will talk about 'the decisive moment', that elusive moment that can make or break a photograph, the instant when a good photo becomes a great one.

Getting the timing right is all about recognizing when a subject is ideally placed or ideally configured in a scene. It's about getting a group of people all looking at their best in a group portrait; getting a child to put on a great expression – and not catching them at that moment that they blink; shooting a fast-moving racing car as it rounds a sharp corner.

There's no magic formula that determines the precise time to shoot. It's something that really does

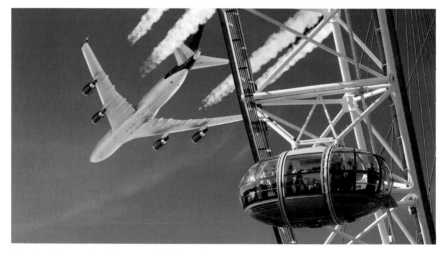

Aircraft and Eye: Here's a prime example of a shot where the timing was critical. A split second early or later and the shot would have been lost, or certainly lost its impact.

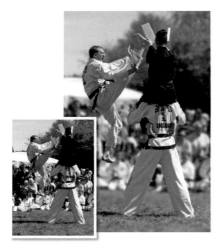

come with practice. It's also something for which you can take out insurance. Smartphone cameras will often let you take two, three or more photos in quick succession. That might be automatically or simply by pressing the shutter release repeatedly. That way, should a subject blink on one, you'll capture them wide-eyed in the next.

Taekwondo demonstration: A demonstration of the skills of taekwondo inevitably ends up with some showpiece action, in this case splitting planks of wood using a kick. To be effective the shot needs to capture the actual event: a moment earlier and you'd see only an approaching foot. A fraction of a second later and it's the shards of wood flying away.

To provide further emphasis on the performers here, the Tadaa SLR app has been used to blur away the background (original image inset).

SHUTTER LAG

You compose a shot, press the button, and the job's done, right? In most cases, yes. That's all there is to it. When you get into the realm of fast-moving action, however, you might find things don't go precisely according to plan. You'll hit the shutter release button and find you don't see the shot you planned, but rather the aftermath of the scene. What's going on?

It's something that's been the bane of photographers' lives since the modern camera was invented. Digital cameras have to a degree exacerbated the problem. It's called shutter lag and simply means that when you press the shutter release you don't necessarily get the shot precisely at that point: there's a brief lag. It may only be milliseconds, but that's enough to compromise a high-speed shot.

How do you avoid it? Once you've ascertained the degree of shutter lag (it varies from smartphone to smartphone) you need to make allowance, pressing the shutter release slightly ahead of the precise moment you were aiming for. Or, when tracking fast action, keeping the camera moving after you've pressed the shutter. Practice makes perfect.

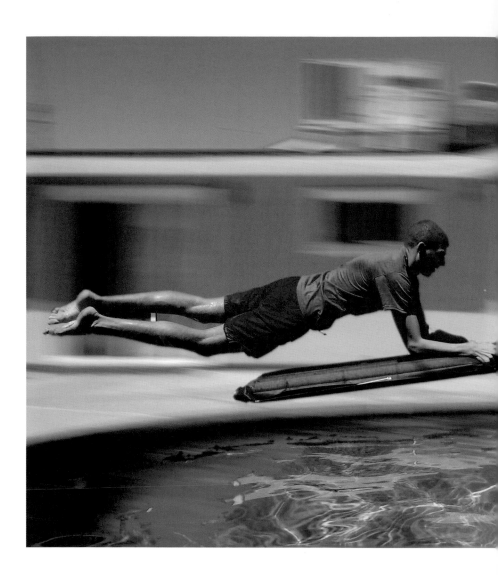

TIMING IN THE LANDSCAPE

I was a little disparaging about timing in landscape photography at the outset of this section. Of course, timing is important in landscape, it's just that we don't need the split-second accuracy demanded in, say, sports.

If you aim to get the best from your landscape then timing is very important. The first rays of sunlight picking out the brow of a hill at dawn will create a more compelling image than the same view shot under a bland blue sky at midday. A cloudy sky may not itself produce a great photo, but that shaft of light that momentarily appears will do.

Timing in landscape photography is more about patience than about hair-splitting timing, about developing an eye for the changes time of day – and weather – will bring.

Body boarder: Another shot where timing is critical, particularly in terms of composition. Shots of fast-moving subjects like this are most effective when the subject is moving towards the centre of the shot. Further to the left or to the right, past the halfway point in the frame, and the shot would lose much of the impact. (Courtesy Nokia)

LEADING LINES

Using lines in your photos is a great way to add structure and drama. When we look at any view (and more so in a photograph) our eyes are naturally drawn along any lines. Depending on the direction of the lines, they will either draw us across the view or pull us in, adding depth to the scene.

You can use bold, straight lines for a formal structure or softer, curved lines for a more informal approach.

Zoom in on regular lines (such as furrows in a ploughed field, rows of windows on a tall building) to produce simple images that enhance the patterns. Or use other lines to lead the eye through the scene.

Roads or railways are great for leading the eye through a scene, especially if there is an interesting subject or highlight at the – literally – end of the road.

It's worth focusing on leading lines when shooting to make sure you get the results you expect. For example, the presence of other

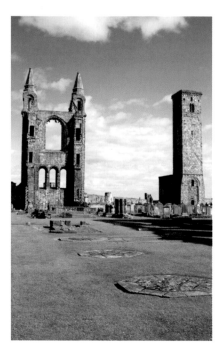

Cathedral ruin: A leading line need not be literally a line. In this case the leading line – which leads the eye along the nave of this cathedral ruin to the main gable wall – is composed of the footings of long lost pillars. A Technicolor effect app helps accentuate the difference in colour between the stonework and the grass.

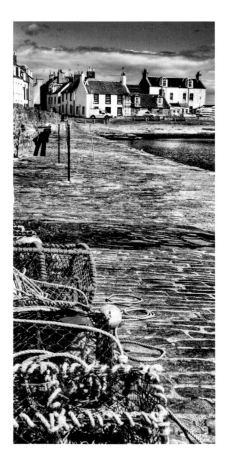

Socttish harbour: This shot of a Scottish harbour, at Ccllardyke, uses the quayside as an informal line to lead the eye to the cottages at the far end. Lobster pots and other fishing paraphernalia have been used to create foreground interest. Finally, PhotoToaster's XPro effect was applied to give bolder, slightly aged colours to the shot.

conflicting lines can have the opposite effect of drawing your eye away from the subject.

ADDING DEPTH

Leading lines that draw your eye into a photo are great for giving more depth to a scene, but for more convincing depth we can go a step further.

All too often when we shoot distant scenes we don't pay much attention to the foreground. The result is that our eyes are drawn into the distance but the scene is rather flat. By including leading lines we can begin to add some depth but if we also add some foreground interest the results can be much more effective. As in the real world, we look past foreground objects to the more distant elements, giving us that enhanced sense of depth (see also Framing, page 70).

◯ TIP
KEEP IT LEVEL

If you are using bold horizontal or vertical lines in a scene, make sure they are truly level. It's remarkable how adept our eyes are at detecting lines that vary from the horizontal or vertical by the smallest amount. If you do want to vary from the horizontal make sure you do so in a very obvious way, so there's no ambiguity.

GETTING THE LIGHT RIGHT

Getting the light right is critical when taking any photo. The angle, intensity and type of lighting can make or break a photo. A conventional digital camera can accommodate light conditions through its various controls and often we don't give them a second thought, but on a smartphone camera you often don't have that luxury. For a great shot you need to make sure the light is right – or as good as you can get – before pressing the shutter release.

Unlike our eyes, which can rapidly adapt to different light levels, camera sensors are less forgiving. Faced with large areas of bright and dark in a scene they won't be able to record everything effectively. A good rule of thumb is to expose for the brighter part of the scene as it is easier to recover detail in dark shadow later.

⬤ PRO TIP
THE DIRECTION OF LIGHT

Unlike digital cameras that often have lens hoods to prevent light sources shining directly or obliquely into the lens and causing distracting flare and hazing in photos, you will have to manually shield your smart camera by either adjusting your position slightly or using your hand, carefully, to shade the lens from the light. Alternatively you could use the flare boldly as a creative element in your image.

Side-lit dolphin: Flare is a potential problem with camera phones but shading the lens with your hand can deliver a flare-free shot.

SHOOTING ON BRIGHT, SUNNY DAYS

In general the more light, the better the results. This is especially true when shooting landscapes, where you want as much of the scene in sharp focus as possible. Bright, sunny days are great for this, and you'll get better results when the sun is to one side of you, rather than straight behind you. You'll get more shading and depth – but do be vigilant and watch out for large expanses of dark, featureless shadow.

SHOOTING IN THE SHADE

If you're shooting portraits, whether formal or informal, doing so in the shade can give more even lighting and prevents your subjects wincing or grimacing from the bright sun. Yes the light levels will be lower, and you may not be able to keep the whole scene in focus, but for portraits that's ideal: keep the subject sharp and emphasized by a blurred background.

HOW DID YOU SHOOT THAT?

In shaded light the camera lens on a smartphone selects a wider aperture, meaning the amount of a scene in sharp focus is limited. This is great for portrait style shots like the photo on the right, because it renders the background slightly out of focus. Set the focus on the subject (touching the LCD panel at the appropriate point) and hold the phone (in this case a Galaxy Note III) as steadily as you can for a pin-sharp result.

Venetian scene (top): Shooting in full sun almost guarantees vivid colours and sharp images – just watch out for shadow areas that can adversely affect results.

Clown portrait: Shooting in shaded light gives more even results, though you'll find the depth of field (amount of scene in sharp focus) is smaller – great for portraits, but less so for landscape shots.

KEEP IT STEADY

Despite all the technical wizardry built into smartphone cameras – all designed to help you get great shots – there's one weak point in the shooting process still. Camera shake.

Try as you might, it's all too easy to let your smartphone move when you are shooting. On the brightest of days this is rarely a problem. Exposure times are so short that even if your smartphone moved during the exposure the effect would be negligible.

Zoom in, though, and the problem will be magnified to the point of making the picture unsharp. And when the light levels fall and exposure times creep up, the problem is also aggravated.

So, what can you do? The obvious – and dare I say it, slightly crass – answer is to say 'hold your camera steady'. It's unfortunate that the nature of smartphone cameras means holding them with one hand whilst releasing the shutter (and perhaps choosing a pre-focus point) with the other, which is not ideal. You can, though, take some simple steps when shooting in situations such as low light where shake will almost be inevitable:

Camera shake: A disappointing result from a colourful scene; low light levels and long exposure times will conspire to produce blurry shots. But brace or support the camera and you'll get – as here – pin-sharp results

- Rest your camera on a firm support. A table, a chair or even braced against a wall or other support.

- Use a lump of modelling clay, or that stuff you use to put posters on the wall, to steady your camera at an angle on a support – though make sure you don't let any of the 'stuff' get in the speaker or microphone holes on your smartphone.

- Use a dedicated support bracket that can attach to a tripod or similar. Okay, this makes your smartphone camera less pocketable, but it's perfect for those tough, vibration-prone situations. You can even use it – by gently rotating – to take perfect sweep panoramic shots.

VIBRATION CONTROL TECHNOLOGY

If you're familiar with conventional cameras you may well be familiar with vibration control technology. Built into many cameras and lenses, it's a pretty successful way of reducing the impact of camera shake by using gyroscopes, servo-motors or digital technologies to compensate for shake. It means you can shoot at lower shutter speeds than would otherwise be possible.

This technology is making an appearance in some smartphone cameras too, so soon camera shake may be a thing of the past.

Bracket: This adjustable bracket costs surprisingly little and can mount your smartphone camera on a tripod or, as here, one of those fiendishly adaptable GorillaPods.

SEEING
THE LIGHT

It may be stating the obvious but light is essential for all photos. Light, after all, provides the illumination that we record in those photos. For good photos you're going to need good lighting so identifying what lighting can be considered good – and what is less so – is a key skill for the photographer.

GOOD LIGHT

So what do photographers consider to be good light? It's light that has an obvious direction and has colour. It's that light which you find in the early part of the day – and the later part – that not only has warmer tones but also a strong and obvious direction, characterized by bold shadows.

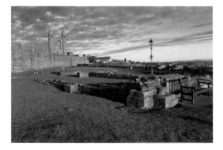

Warm lighting: Shooting in the first part of the day exploits the warm light characteristic of this time. Bold, long shadows add to the effect – though it's important to make sure you don't add your own shadow to the shot.

BAD LIGHT

To say some lighting is 'bad' is perhaps a bit extreme – but it is fair to say that some lighting conditions are less likely to deliver pleasing photos. The middle of the day is a good case in point. It's a time when many of us get our cameras out and shoot away. Colours are bright – assuming the sun is out – but the virtual lack of shadows doesn't give photos sufficient depth.

When the skies are overcast the results are generally similar in regard to the lighting but with colours that, like the scene itself, are somewhat flat.

Much the same can be said for flash lighting, which delivers an even burst of light to the scene (giving no shadows or toning), with the additional problem that the lighting tails away rapidly for more distant objects.

CONTRE-JOUR

There's a form of lighting that can be both good or bad, depending on how it is used. That's when the light is behind the subject. It can produce delicate backlighting that enlivens colours or it can render subjects as bland – and often unintentional – silhouettes. Photographers call this by the rather grand term contre-jour – or 'against daylight'.

Back lighting: Shooting with the sun behind the subject can be problematic but can also produce some powerful, evocative shots. Here the sun itself is masked but the softer reflections provide the illumination. A touch of morning mist adds to the atmosphere, as does the application of a mild warming effect from the PhotoToaster app. Bags of character and a picture that comes to life by virtue of the way it's lit.

SIMPLIFY THE SCENE

When you first come upon a bright, vibrant scene – an urban landscape for example – it can be tempting to try and take a photo that captures it all in one go. Such shots are rarely successful as they present anyone viewing the shot with too many points of interest. What is the subject? What's important in the scene? You may have a clear idea, but your audience as they explore the shot may not be so sure.

It's better to be more circumspect about what you include in a shot. Look for the details. In fact, the adage 'less is more' has never been more relevant than in these situations. When you pare down your shot to concentrate on just one point of interest there is no ambiguity as to what is important.

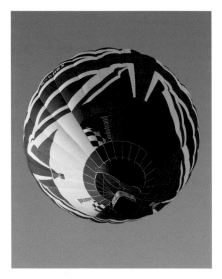

Simplifying a scene: An event like this balloon fiesta is a riot of colour and shape and the urge is to try and catch as much as possible. There's no doubt that this can produce a colourful image, but it's also one that's a touch chaotic. What is the subject? Where do you look first? In truth there is nothing pre-eminent to which our eyes should be drawn first.

By concentrating on a single balloon envelope we get a much more promising image where it is clear what the subject is. And although it's a much simpler image there's still plenty for anyone viewing it to explore.

Racing gig: The Cornish harbour town of Porthleven is rightly considered photogenic. It's packed with photo opportunities but all too often visitors try to cram in too much of the view in one go. Much better to look at attractive – but simple – details. For example, the racing gig – a Cornish peculiarity – in the foreground of the general view.

Getting in closer and focusing just on the gig produces a much more powerful – and detailed image, particularly when shot here in a symmetrical composition.

● TIP

GRAPHIC IMAGE

When you've got a bold, simple image you can give it an alternative treatment by applying a posterizing or painterly effect – which gives a bold, graphic look. Try Photo Editor (Android) or Poster Me (iOS).

Posterize: Posterizing effects can further simplify an image and produce a bold graphic.

SHAPE
AND COLOUR

If there's something that marks the more experienced photographer from the less, it's the way that the former will tend to include less in their photos. When we first shoot a photo we tend to be oblivious to all the peripheral elements that can appear in the shot. The results are often good but slightly cluttered shots.

Then, as our experience grows, we become more conscious of what is important; what needs to be included – and, more specifically, what doesn't. We also begin to realize what produces power and impact in shots. Here are a few examples.

BOLD SHAPES

Shapes add structure to your images. In their most basic form shapes are essentially little more than silhouettes viewed against plain – or relatively plain – backgrounds.

Silhouettes: A silhouette is a simple way to represent a bold shape. A shot like this was taken by exposing for the mid tones in the sky. That ensures there's an even range of bright and dark in the sky and the silhouette retains a touch of shading detail so as to avoid becoming overly two-dimensional.

The shapes you use can be obvious in form or can be a bit more abstract. A photo such as this invites a degree of questioning as to its nature (a close up of some special-shape hot air balloons) but the contrasting shape (and colour) draws us to explore the photo.

CONTRASTING COLOUR

Colour can itself be a powerful element in composition. When contrasting colours are brought together they tend to clash. That can result in an image that's a touch chaotic and difficult to look at or, conversely, one that is particularly bold.

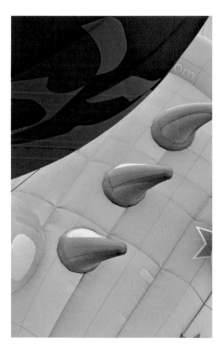

Simple shapes: Bold, graphic shapes can be as simple as this, merely a patch of sky and its reflection in a mirrored building.

Shape and colour: This combination of unusual shapes and colours encourages us to look more deeply into the photo, unlike some photos that are simple and obvious in their nature and are judged purely on their pictorial value.

Pennant flags: Orange and cyan are colours that don't normally sit together well – unless you are after deliberate drama – but the combination works here as the coloured flags share a common shape and the scene is softened by the blue background.

BACKGROUNDS

How often, when shooting what you consider to be a perfect shot, have you ended up disappointed because your bold subject has ended up merging into – or competing for attention with – a busy background? If your answer is 'never' then be assured that time will come!

We talked earlier about how the eye is remarkably adept at recording a wider range of brightnesses of light than the camera can accommodate. Similarly the camera can't discriminate between your intended subject and what lies beyond. The result is often a melange in which the subject is not sufficiently defined.

So how do you give your subject more prominence? Often it can be as simple as placing your subject in front of something less distracting, a plain background or at least something that exhibits a more limited colour palette – a foliage hedge, for example.

Putting more distance between your subject and the background can also help: the greater

Dark background: A dark – or black – background is a great way to isolate a subject although it doesn't work with all subjects. It's very dramatic – so ideal for shots like this.

the distance between the subject and background, the less sharp the background will become, again rendering the subject more prominent. Go further by standing back and using the smartphone camera's zoom lens. This will render the background more blurred, also increasing the prominence of the subject.

Get in close: Shooting close up will generally render a background out of focus, more so when the light levels are lower, so the lens aperture (on cameras with variable apertures) is larger. If the subject and background are still too close in focus terms then you can always resort to an artificial – but realistic – fix, such as that shown below.

AN APP-BASED SOLUTION

Sometimes you just can't configure your shots to produce a better background. There may not be an alternative or you may have already taken your shots. All is not lost. You can use an application like Tadaa SLR to retrospectively add a blurred background.

Apps like this work by letting you select the background and then applying a blur. Varying the amount of blur will give different effects: aim for a modest amount of blur that gives a more realistic effect.

Forcing a background: Apps like Tadaa SLR let you exaggerate the degree of blurring of a background. Use your finger to select the subject (which then turns green to show it's protected). Then you can apply a blur to the remaining, unmasked areas.

LANDSCAPE OR PORTRAIT? SQUARE OR PANORAMIC?

Your smartphone camera gives you the options of four formats, without having to resort to the crop tool: portrait, landscape, square and panoramic.

PORTRAIT AND LANDSCAPE

The default rectangular format if you're holding your camera horizontally is landscape and, if turned through 90 degrees, portrait. Don't set too much store by the names: you can take some great landscape photos with the camera held in portrait format and, of course, some great portraits in landscape mode.

These modes will ultimately give you the highest quality as they are the ones that use the full size of your camera's imaging chip.

SQUARE

Can't decide whether something looks better in portrait or landscape format? Give the square format a go. In the days before digital photography, square format images tended to be the preserve of professional cameras, including the professional's ultimate, the Hasselblad, but now, thanks to apps such as Instagram, they're pretty commonplace. You can compose shots in exactly the same way using the square format, but it's particularly effective for big, punchy, frame-filling subjects.

Portrait format (above): Don't reserve this flexible format just for conventional portraits. Let your subjects dictate the best format to use. This scene would lose impact if shot in landscape format, either reducing the size of the subject or trimming the imposing buildings.

It's smart to be square (right): The square format is perfect for bold frame-filling subjects

PANORAMIC

With the right subject, panoramas can be breath taking. That broad, sweeping view can't fail to impress, although to get the full impact you'll need to view it as a large print or screen.

Cameras differ slightly in the way that they record panoramas – some do so by sweeping around the view you want to capture, others grab shots consecutively as you move around. You can also find software apps (for your smartphone or computer) that will stitch together individual shots, useful if you want to edit your photos before combining.

When shooting a panorama it's important to fill the extended frame with your view and not have too much sky. And, as ever, don't neglect composition. A strong subject in the frame gives your eye somewhere to land before exploring the rest of the scene.

⬤ TIP
CROP FOR PERFECTION

Sometimes none of these formats are just right for your subject. The best format might be one that's nearly square. Or wider than landscape but not a full panorama. Don't forget you can crop your images using the camera's Photos editing tools to almost any dimensions.

The Grand Canal, Venice (below): Shot so often it's almost a cliché, the Grand Canal – and Venice itself – is rightly regarded one of the world's most photogenic locations. This panorama features the Campanile at St Mark's Square as the notional subject from where we can explore the magnificent buildings that line the north shore.

Clifton Bridge (above): Sometimes a subject will suggest its own format. This view of the Brunel's Clifton Suspension Bridge in Bristol was originally shot as a broad panorama but there was a lot of the scene to the left that contained nothing of interest. Cropping the panorama produces something much more attractive. App applied: Phototoaster B/W

SHOOT THE EVERYDAY

You don't need to head off on a mission or cross the globe to get great photos. True, there are some places that provide compelling photo opportunities at every turn but often the very action of travelling to an exotic location can overwhelm our carefully honed photographic skills and we end up shooting the most exciting of locations in the most pedestrian way.

Becoming a good photographer – or even a great one – is not about seeking out the exotic. It's about seeing the opportunities all around you. They might be obvious, they might be less so. And with a smartphone camera you've the advantage that you can apply a filter or app immediately to help

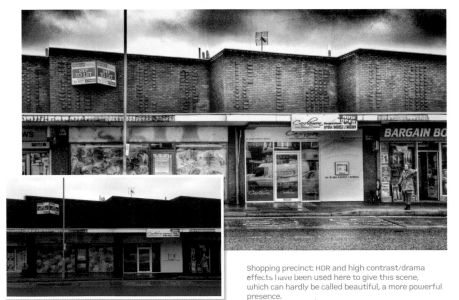

Shopping precinct: HDR and high contrast/drama effects have been used here to give this scene, which can hardly be called beautiful, a more powerful presence.

interpret your photos. Here's just a couple of examples of subjects we might normally not consider but which can ultimately produce some great shots.

Shooting the everyday is also great for focusing your mind on what makes a good photo. Some subjects are obvious: imagine those views you might get around town. You're really familiar with them and can quickly use the rules of composition to construct a technically great shot. But how does light affect the scene? How does it look under different weather conditions? Shooting the same scene at different times of day, different times of the year and you can quickly come to recognise what lighting conditions are flattering, and which less so.

Don't forget, either, the small details of everyday life. These too can help you create good images and deliver interesting – if not award winning – photos.

A bold 'Polaroid film' effect frame has been added to this shot (below left) for good measure, using the PhotoToaster app.

Flower pot: Colours are always a winner in photos and shots of colourful flower borders are a favourite with many photographers. Look, though, for more unusual interpretations. Low angles and backlighting, for example. Shoot flowers from below using the smartphone camera's forward-facing camera so that you can easily preview your shot. Add even more drama by using a vivid colour or high-saturation effect.

Lunch: Taking photos of meals with smartphones has become quite contentious, with restaurateurs taking issue with diners. Avoid the controversy and you can create some interesting still-life shots.

SHOOTING IN
THE GOLDEN HOUR

Ask any photographer what time of day is best for taking photos and many – if not all – will say the Golden Hour. The Golden Hour? It's that magical time just after sunrise, and just before sunset, when the sun is low. The light it casts is a warm amber or rose colour and the low angle casts long, deep shadows.

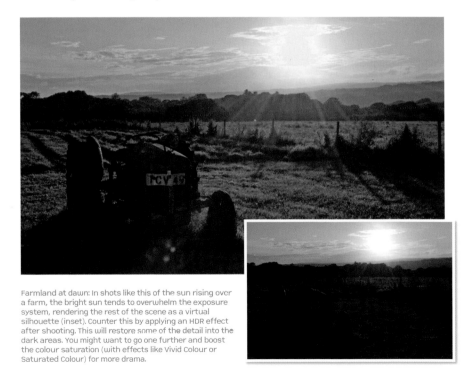

Farmland at dawn: In shots like this of the sun rising over a farm, the bright sun tends to overwhelm the exposure system, rendering the rest of the scene as a virtual silhouette (inset). Counter this by applying an HDR effect after shooting. This will restore some of the detail into the dark areas. You might want to go one further and boost the colour saturation (with effects like Vivid Colour or Saturated Colour) for more drama.

Of course, this captivating time is not strictly an hour – it's often shorter in the bright summer sun and somewhat longer in winter. Depending on the time of year, you may also get some interesting weather effects – such as mists, fog and dew – that can add to the pictorial qualities.

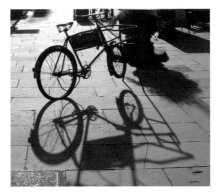

Bicycle: The Golden Hour is the perfect time to shoot photos if you like bold graphic images. The high-contrast lighting (despised by photographers at other times of day) will help create some powerful images. Look out for scenes like this where the sun projects deep, long shadows that are often more bold than the subjects that cast them.

◯ TIP

EMPHASIZING THE GOLDEN HOUR

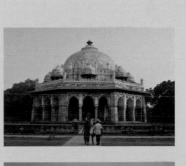

Use filters and apps that add warmth and colour saturation to further emphasize the warm colours in your scene. You can also try using HDR effects to add a little bit of detail into some of the deep shadow areas.

It can often be really pleasing to discover how much colour information your smartphone camera records in shadow areas. In this photo of Isa Khan's Tomb in New Delhi, India, an attractive scene is rendered somewhat more colourful by application of an HDR effect and modest increase in saturation.

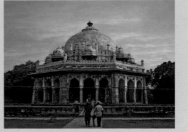

Shoot the everyday.

Colour and shape – with a touch of a grunge app.

GETTING THE
BEST FROM...

What is it that excites you about taking photos? Shooting memories of friends and family? Recording important family events? Those fantastic trips to exotic locations? Your favourite sports, perhaps?

It could be all of those – and more. Photography is compelling. Once you start shooting you're continually looking for new opportunities and new subjects. And when you've got your camera – a smartphone camera – you'll have it with you all the time and start to see the possibilities in even the most mundane of subjects.

Each genre of photography, though, makes different demands on your photographic skills, so over the next few pages we're going to examine some of the more popular photo subjects and look at ways of getting the best from them. We'll also look at what we can do to take our photos further – going beyond the straight, conventional shots and creating something more artistic, something more powerful.

I hope these prove inspiring but, as ever, don't feel constrained by the ideas, tips or rules; rather use them as a Launchpad to help develop your own photographic style.

GETTING THE BEST FROM YOUR SMARTPHONE

If you observe the way a pro photographer works, you'll see that they have a vast arsenal of photographic equipment from which they'll pick the most relevant tools – cameras, lenses and accessories – for each assignment they tackle. With a smartphone camera we don't have the same ability to pick and choose components so we need to be a bit more circumspect in how we approach different photographic topics.

Let's take a look at those we'll cover in this chapter and summarize the benefits of using a smartphone.

HOLIDAYS AND TRAVEL: PAGE 106

Travel not only broadens the mind, it also provides some great photo opportunities. Use your smartphone camera for great candid shots wherever you may be, without attracting undue attention. You can use a smartphone in situations where, as a general rule, you'd be banned or restricted in using a conventional camera, providing many more photo opportunities.

PEOPLE: PAGE 110

The ubiquity of smartphones means that portrait-style photography is now less intimidating for the subjects; they are more comfortable in the presence of a camera. The small form factor of a smartphone also means it's easy to get candid shots. In any case your people photography will appear much less formal and staged.

CHILDREN AND PETS: PAGE 114

Children and pets can be conveniently considered together since, as we'll find out later, they are equally testing when it comes to performing for the camera. Candids are almost order of the day. Not all children – or pets for that matter – are difficult though, so if you've a child or pooch who has an affinity for the camera, it's something to be cherished. Shoot lots so you'll up the chances of getting a great shot.

SPECIAL OCCASIONS: PAGE 118

A special occasion is one of those times even the most reluctant of camera users will grab a camera and shoot some photos. Think of weddings, for example, when hundreds – maybe thousands – of photos are taken. You can rely on the professional photographer to get the standard posed shots but use a smartphone camera to get some new and different angles – literally – on such events.

NATURE & OPEN SPACES: PAGE 122

Landscape photography is popular with just about all photographers even if they don't admit to it. Who can fail to be impressed by a stunning view bursting with colour? It's easy, though, to be seduced by the bigger picture and not notice details. Smartphone cameras are just perfect for getting in close with those small details and delicate forms that nature gives us in every season.

THE URBAN LANDSCAPE: PAGE 126

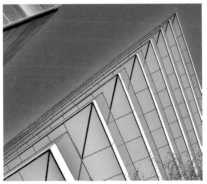

Far from being dull and prosaic, the urban landscape can be packed with colours, textures and shapes that can provide more testing opportunities than the rural landscape. The broad mix of architecture and design in a typical town or city gives vent for creative opportunities whether you've a preference for photorealism or something more abstract. Use your smartphone as a visual notebook to record these.

URBAN ART: PAGE 130

The urban landscape can sometimes be even more colourful as it provides an intriguing canvas for some of the more imaginative – and controversial – of contemporary artists. It can be challenging to capture urban art in context but using a smartphone camera can attract less attention than using a conventional camera.

ACTION PHOTOGRAPHY: PAGE 134

Action sports photographers are often armed with very powerful kit – large, wide-aperture lenses, perfect for freezing fast action and catching it close up. A smartphone camera is an entirely different beast so we'll discover how we can make any shortcomings into a virtue.

NIGHT & LOW LIGHT: PAGE 138

As with action and sports photography, shooting when the light levels fall can be problematic for smartphone cameras that are designed for use in 'normal' lighting conditions – daylight. But push the limits of your smartphone camera and you can end up with some really compelling and atmospheric shots.

STILL LIFE: PAGE 142

If you ever feel that circumstances – or perhaps the weather – are conspiring to prevent you from getting the perfect shot, then it's time to start exploring still-life photography. It's a genre that gives you complete control over the scene and the opportunity to build a modest – or even impromptu – studio around your smartphone camera.

THEMES: PAGE 146

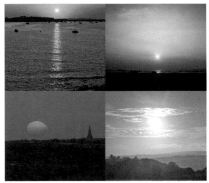

Photography can be an all-consuming passion but can also be frustrating. Frustrating when you think there's nothing to photograph. Focusing on themes gives you something to shoot when you've no opportunity to shoot your (other) favourite topics - and is a great way to perfect your skills.

INTERIORS & TIGHT SPACES: PAGE 154

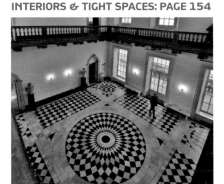

Not so much a genre as a situation. It's surprising how we can sometimes overestimate our smartphone camera's angle of view – the amount of a scene it can record. That applies particularly if you're faced with a cramped or constrained interior: you'll be able to shoot very little in one go. So we have to think laterally if we're going to successfully record spectacular interiors.

CONCERTS, THEATRE AND FESTIVALS: PAGE 150

Extreme lighting, erratic movement, powerful colours – all of these (and more) will fool your smartphone camera's exposure and colour balance systems. But compensate for them and you can get some stunning images from those once-in-a-lifetime (or once-a-year) events.

HOW GOOD?

So how effective is a smartphone camera at effectively letting you shoot each of these topics? I've given my assessment for each as a star rating. One for the effectiveness of the camera itself and the second for the creative opportunities.

TRAVEL

It could be a day out with friends or a longer trip with family. Holidays and travel are an excellent excuse to use our smartphone cameras as much as possible.

The beauty of a smartphone camera – apart from the photos it takes – is that it really is small enough to take everywhere, whether relaxing or sightseeing or going for an evening meal, so there's no excuse for missing any photo opportunity. We can get some great portraits and group shots of our travelling companions enjoying themselves, or simply having fun on the beach.

LOOK OUT FOR

• Candid photo opportunities: shoot photos with a camera phone and you are less likely to attract attention compared to someone using something more serious looking.

• Local sensitivities: culturally and politically you may not be free to photograph anything and everything when travelling. Avoid photographing around airports or military installations and get advice about locations such as places of worship.

• Local colour: do your homework before leaving to ensure you don't miss some photographically spectacular places, or events.

• Subtle details and new angles: some landmarks have clichéd viewpoints so seek out something – or somewhere – a little more original.

Leading lines: Exploring new locations is the perfect way to practise those rules of composition such as using lines, as here. The causeway that links to the mainland at low tide has been used to lead the eye to the part-time island of St Michael's Mount in the south-west of England.

TIPS

• Landscapes and cityscapes can change dramatically according to the time of day and the weather. Don't be afraid to pay a return visit to capture a scene in – literally – quite a different light.

• Don't forget that as well as being a camera, your smartphone can also provide you with plenty of online and offline – downloaded – information on your location, from weather to interesting places to visit.

• Use the voice recording feature on your smartphone to make any notes – such as the name of a picturesque location or a dramatic building. It's so easy to forget important details when you get home.

HOW DID YOU SHOOT THAT?

This river scene is packed with activity. Rather than a straight shot – which would have included a fair bit of less interesting sky and foreground, I opted for a panoramic approach. Panoramas are usually produced by panning the camera around the scene, building up the panorama in stages. That would have been slightly problematic here as the moving vessels would have blurred or produced unwanted artefacts (odd image errors).

Instead the three photos were taken and then stitched together using Stitch Panorama (iOS). PanoStitch Panorama Picture HD is a similar app for Android Phones.

For a final flourish a modest amount (40%) of HDR effect was applied followed by an art effect.

River panorama: Some views really are too grand to capture in a single shot and demand the panoramic treatment.

VARIATIONS ON THE THEME:
TRAVEL

Changing tides (above): If you're visiting coastal locations the landscape can be transformed as the tide rolls in. Look out for boats languishing in the mud when the tide is out but bobbing about in the harbour just a few hours later as the water returns.

At high water, check the composition you use: a symmetrical composition can work well when you have bold reflections.

In the shot here showing the low-water scene, the saturation was increased slightly to boost the colours under a somewhat muted sky. No such treatment was needed for the second shot, brightly lit under a strong summer sky.

Changing weather (opposite): It can sometimes be disappointing to visit a popular and photogenic location to find the scene somewhat more drab than you expected. Sadly, the photos we see in most guidebooks were taken in the best conditions – and usually have a bit of a saturation boost just to make them look even better.

Don't be dismayed though: make the best of what you have. And if the schedule permits, visit again when the weather has changed. Here the original shot of this cottage was under a grey overcast day. But by using Snapseed's Drama filter we get something more... well, dramatic! This is a great way to pep up any grey-day shots, giving the sky a much more theatrical appearance. And just a few hours later our perseverance was rewarded with a warm, pastel-coloured sunset, giving the same scene a warm glow.

PEOPLE

CAMERA ✳ ✳ ✳ ✳
CREATIVE ✳ ✳ ✳ ✳

We just love to shoot photos of people, whether strangers or each other or... ourselves. There are just so many ways to photograph people – from a formal portrait though informal ones and on to the ubiquitous self-portrait, the selfie. Whatever it may be, it's photos of people that seem to be the most shared and which figure prominently in people's photo streams.

Professional photographers will lecture you on the difficulty of shooting a successful portrait and point to the skills – in composition, lighting and more – required. Fortunately with just a few apps on your smartphone you can shoot portraits and candids of people that may not follow the same rules but are just as interesting. And often, a great deal more personal.

LOOK OUT FOR

• Image sharpness: smartphones are pretty adept at keeping a broad swathe of the image in perfect sharpness but ensure that you keep the face itself (and especially the eyes) pin sharp for maximum impact.

• Backgrounds: it's all too easy to pay attention to the subject but ignore its surroundings. Make sure – if you can – you set a portrait shot against a plain background. If that's impossible we can always apply a corrective app later – such as Tadaa SLR – to blur away the background.

• Blinking: if you've experience of shooting people it's surprising how many photos show

Selfies: Quick fun portraits. Just remember that the forward facing camera tends to be of lower resolution than the main, so don't expect critically sharp images; perhaps apply an app effect to enliven the result.

people blinking. No matter how subjects try to keep their eyes open they always seem to blink at the moment of exposure. Reduce the risk by shooting off several shots in quick succession. This often has the additional benefit of catching the subjects a little more relaxed and less tense.

• Unusual angles: As we discussed on page 66, shooting people from unusual angles can produce imaginative portraits.

As we discussed on page 66

TIPS

• Watch the light – bright sunshine is great for bright colours and impact, but can cause your subjects to squint.

• Overexpose your shots (slightly), either when shooting or later to give a bright perky look to your subjects.

• Consider applying a soft-focus effect to portraits if you want to give them a romantic feel.

HOW DID YOU SHOOT THAT?

Some people's faces just project character and that was the case with this wood turner working on a lathe at a craft fair. He was deeply engrossed with his work – as he needed to be – so it was an excellent opportunity for a candid shot.

The only problem was that the sun was broadly behind him, casting his face into shadow. No matter, we can correct that later. It was important in the composition to include the lathe: this would put the subject into context.

Once shot, an exposure-adjusting app was used to overcome that modest amount of underexposure in the subject's face. At the same time, to give the character a more gritty appearance the sharpness was increased. Finally the image was given the black and white treatment followed by a rustic 'sepia' tone.

Wood turner: An intense, focused expression, characterful face and powerful context conspire to produce a bold informal portrait of this wood turner at his work.

VARIATIONS ON THE THEME:
PEOPLE

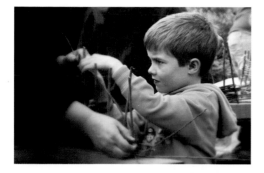

Have fun (left): Smartphone photography is about having fun, so shoot some playful impromptu portraits. Having a smartphone with you all the time means people's resistance to being photographed is diminished so you can easily grab fun images. PhotoToaster's Dusk effect gives this portrait a warm feel and a touch of a vignette.

Small boy (above, top): Reduce the impact of a cluttered background or surroundings by applying a centre-focus effect. This will keep the subject – here the little boy – sharp, but gently soften (and optionally darken) the surroundings.

In the thick of it (above): The beauty of a smartphone is that you really can take it with you everywhere – and catch candid portraits even when you're in the midst of the action, such as catching fellow competitors warming up for a race.

Photo booth (right): Whether shot as a conventional portrait or a group selfie, apply multiple effects to the original image to produce a photo booth-style photo.

CHILDREN AND PETS

CAMERA ⊕ ✶ ✶ ✶ ✶ ✶
CREATIVE ✶ ✶ ✶ ✶

Ask pro photographers what subjects fill them with trepidation and many will say children and pets. Short attention spans and pure cussedness can conspire to make good shots difficult. You need a special approach to photographing children and pets; think of it less as a type of people photography and more a special version of action photography.

Fortunately, as with candid people photography, a smartphone camera is less intimidating for your subjects (compared to a conventional camera), human or otherwise, and can give you more freedom of placement. Any other skills needed? Just patience. And the understanding that you're going to need to shoot lots and lots.

LOOK OUT FOR

• Interesting shooting positions. Get your camera down low to shoot pets from their point of view – or pan your camera to follow your sprinting dog.

• Special smartphone camera modes. Action shot mode, burst mode and the like (depending on what they may be called on your smartphone) will provide you with multiple shots from which you can choose the best.

• Tiredness. Tired children and pets don't make the best subjects. Their fatigue will be all too obvious in the photos even if they are less animated and therefore easier to shoot.

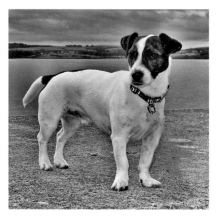

Pet portrait: Who said that pets don't pose for portraits? Okay, so a little luck was involved here along with an over-the-shoulder distraction. The pose and expression lasted just an instant so it was important to be extravagant with the number of shots.

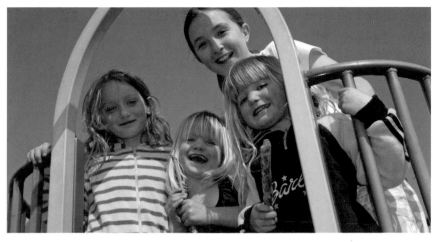

Friends playing: A low angle and burst of fill-in flash was enough to produce this charming portrait. The in-camera shot was perfect and needed no production effects.

• Provide distractions. A child's favourite toy, or a brand new toy, can keep him or her occupied. Or a tasty bone for a dog to chew on. Or get children and pets to play together and distract each other.

• Take an assistant. Someone who can throw a ball for a dog to catch, distract a cat with a toy mouse or interact with – or distract – children.

• Choose a comfortable environment. Children and pets are more relaxed in a familiar environment.

HOW DID YOU SHOOT THAT?

As I've mentioned before, shooting a child from a low angle is empowering. Shooting a group of children is similarly so, but can be difficult to compose. Your smartphone camera won't give you a sufficient angle of view, even if you are lying on the ground below them. So get them into an elevated position. Here the children were standing together on a platform on some playground equipment. I asked the children to tell each other jokes before shooting to make them more relaxed, and shot them as their laughter subsided.

This was also one occasion where the smartphone camera's flash came in useful. The modest light output was sufficient to prevent shadows in the children's faces due to the bright sunlight.

VARIATIONS ON THE THEME:
CHILDREN AND PETS

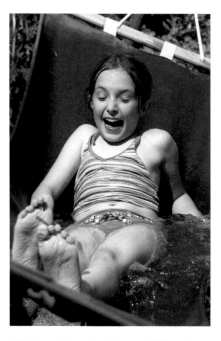

Activities and distractions (this page): Children often lose themselves in activities and games and you can move around with impunity, grabbing shots.

Children and pets (opposite): That has to be a winning combination – and potentially the most difficult. A little perseverance though will hopefully pay off. That and shooting lots so you get at least one shot that's perfect.

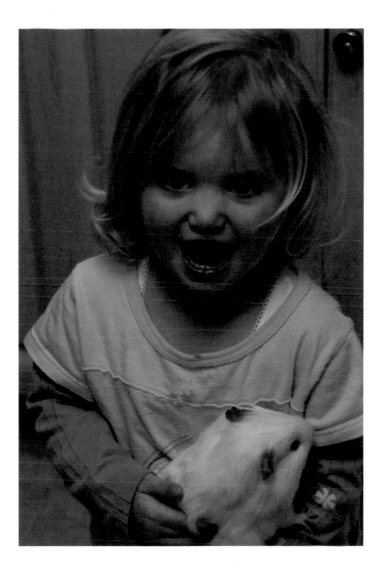

SPECIAL OCCASIONS

The year is peppered with special occasions. Birthdays, anniversaries, weddings, Christmas, New Year... the list can be seemingly endless. It doesn't matter what the celebration or occasion may be, if it's special to you, you'll want to have a photographic record.

LOOK OUT FOR

• Candid shot opportunities. How many photos of wedding breakfasts, anniversary parties or even children's parties have you seen where all the photos of people are stiff portraits? Buck that trend by catching candid shots of people enjoying themselves and being... themselves.

• Colourful lighting. Once the preserve of Christmastime, decorative lighting is used increasingly for more and more celebrations and can produce some great photos. Experiment with exposure and with colour-enhancing apps to bring out the full drama of the lighting.

• Official photographers. Whatever the event, if there's an official photographer leave them to take the official photos – it's what they're being paid for. Don't try to replicate what they shoot but go instead for the more personal shots, the type of shot you can only get if you're familiar with the people.

Romantic dancing: Long exposures can be a boon rather than a weakness when it comes to catching soft dreamy shots like this. All you need are low light levels and somewhere firm to rest your smartphone. Add some soft focus effect to complete the picture.

Christmas: More a season now than an occasion, Christmas produces more photo opportunities than any other time of year.

• Minor occasions. Rite-of-passage events used to be simple and largely based around religious celebrations. In a more secular world there are many occasions that mark turning points in life which almost demand to be photographed. College graduation or passing a driving test, for example.

TIPS

• Don't forget your smartphone has video too. Use it to record those parts of the events that would be more memorable – or more photogenic (should that be moviegenic?) when shot as a movie: the first dance at a wedding breakfast, the rendition of 'Happy Birthday to You' and so on.

• Tell a story. Many occasions, such as weddings, have a definite sequence of events. Get shots of each so that your photos tell a story. It makes your photos much more coherent and a good sequence of photos is ideal for having printed as a keepsake album.

• Get to know the occasion. If you're unfamiliar with an special occasion (perhaps it's something culturally different) find out about the event so you'll be alert to the key moments that make the really great photo opportunities.

HOW DID YOU SHOOT THAT?

The last day of school is a special occasion on various levels, and one that children increasingly celebrate. This portrait of some happy school graduates celebrating their last day was obviously not a traditional candid but with just about everyone in the room using a camera of some form, soon everyone became blasé.

Shooting from a low angle gives everyone more 'presence' and to avoid any unflattering shadows or blemishes, the shot was given a soft focus effect. It was finished off by applying a warming tone app to give the skin tones a touch more warmth and draw everyone's complexions together.

School's out: It's been a hard few years but now schools finished and it's time to relax. At least until the exam results are due.

VARIATIONS ON THE THEME:
SPECIAL OCCASIONS

Close-ups (above): Many occasions see a large number of people getting together. Don't, though, concentrate on only shooting large groups of people, whether formally or informally. Get in close for some one-to-one moments such as this. Despite all that might be going on all around, a close-up captures the intimate expressions between a proud grandfather and his granddaughter. (Courtesy Nokia)

Tell a story (left): For major occasions don't forget some shots that help tell the story. Here a shot of Christmas presents sets the scene for photos that might be taken later in the day of excited children opening them.

Surroundings (opposite): Special occasions are, well, special! And are often held in sumptuous surroundings. Don't get intimidated by the imposing maître d' – get some great shots of your surroundings too.

NATURE AND WIDE OPEN SPACES

Look around those poster stores – whether the bricks-and-mortar kind or their online equivalents – and one type of photo dominates: landscapes. Of all the photos shot on smartphone cameras, landscapes – in the broadest definition of the term – come second, just behind all those photos we take of each other.

It's hardly surprising that landscapes are so popular. Even if they are not what we might call classically beautiful or photogenic, landscapes are evocative and photos of them can remind us of our travels.

LOOK OUT FOR

• The weather. Weather can make or break a landscape photo. Generally speaking,

landscapes look their best in the hour after sunrise and the hour before sunset – assuming clear skies or broken cloud. Then you get the powerful interplay between warm lighting and long shadows. But don't ignore grey skies – which can be boosted later with the application of drama-enhancing effects.

• Seasonal highlights. In spring it's the bright green of new growth; six months on it's the same foliage as it takes on the reds, golds and

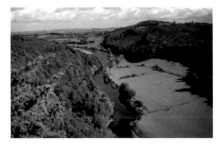
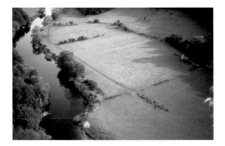

Weather: What a difference a day can make. Or a week in this case. On my first visit to this popular viewpoint on the Wye Valley in Wales there was bright sunlight and a blue sky reflected in the river. A week later overcast skies give a flatter lighting.

yellows of autumn. Winter, of course, brings the snow and frosts that can transform the most humble of landscapes.

• Details in the landscape. Shooting outdoors isn't all about sweeping vistas. Nature can produce some beautiful small-scale shooting opportunities too. Think of a dew-draped spider's web or a rare orchid poking though meadowland grasses. Good opportunities for honing those close-up photography skills.

TIPS

• If you want that timeless landscape shot, try to avoid having people and vehicles in it. These immediately date the scene. But don't be afraid of using landscapes as a background for some impromptu portrait shots of your travelling companions, if you're making a record of your adventures.

• The Rule of Thirds composition is ideal for landscapes and can produce some really powerful shots. As the landscape is rarely compliant when it comes to composition, spend a little time walking around the scene to get it just right.

• Take your time. Unlike some types of photography where you need to grab a shot or you'll miss the moment, being more considered can pay dividends in landscape photography. Waiting for the sun to break through a gap in the clouds, or for the shadows to lengthen a bit, can turn a good photo into a great one.

Lakeside folly: Timing, as much as compositional skill, produced a good image here.

HOW DID YOU SHOOT THAT?

Here's an example of why timing can be critical in landscape photography. The setting of this folly, peering though a gap in trees that surround a lake, suggested a symmetrical composition. In fact there are two lines of symmetry there, horizontal and vertical.

As I was composing the shot a small break in the clouds passed over the landscape and I realized it was heading for the folly. I waited patiently and took the shot when the folly and some of the landscape around it was in full sunlight. The trees on the waterside remained in the shade.

The original shot was compositionally fine but there was too much contrast, so I used an exposure correcting app to brighten the darkest trees slightly then added a touch of HDR. Finally, to warm the image slightly I applied the Sky Drama filter affect from the Stackables app (iOS).

VARIATIONS ON THE THEME:
NATURE AND WIDE OPEN SPACES

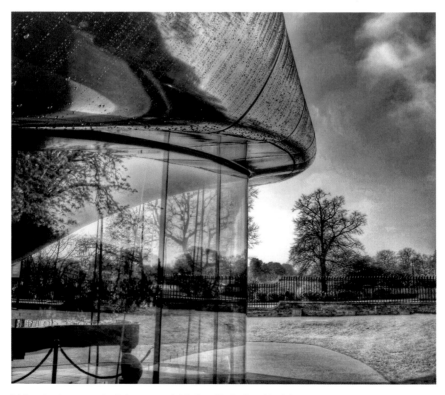

Intrigue: Landscapes can be obvious or more intriguing. This simple parkland view is given a fascinating twist by shooting its reflection in the curved organic lines of the contemporary building (Zaha Hadid's Serpentine Gallery, London).

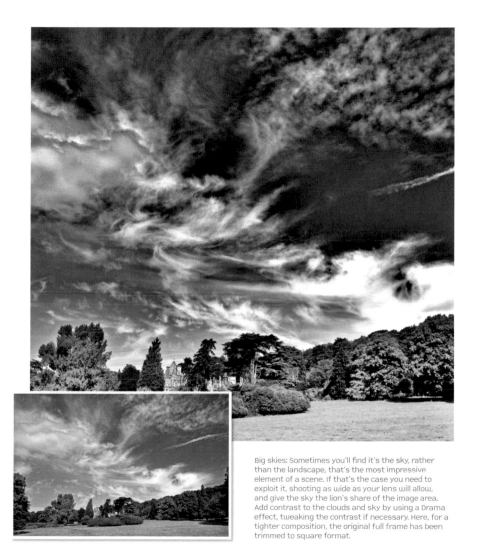

Big skies: Sometimes you'll find it's the sky, rather than the landscape, that's the most impressive element of a scene. If that's the case you need to exploit it, shooting as wide as your lens will allow, and give the sky the lion's share of the image area. Add contrast to the clouds and sky by using a Drama effect, tweaking the contrast if necessary. Here, for a tighter composition, the original full frame has been trimmed to square format.

URBAN
LANDSCAPES

CAMERA * * * *
CREATIVE * * * *

Cityscape photography is often considered nothing more than a poor relation of landscape photography. There's no doubt that the urban environment is a form of landscape, but to dismiss it so is to do it a disservice. The urban landscape offers some brilliant photo opportunities – and some interesting challenges too.

LOOK OUT FOR

• Old and new. The organic growth of cities can produce interesting juxatapositions of old and new architecture.

• Parks. Parkland can produce interesting contrasts in your photos, particularly when shot with the cityscape – and landmark buildings – looming up beyond.

• Perspective. Point your smartphone upwards around tall buildings to get some great exaggerated perspective effects, with the buildings converging above you.

• Street characters. Don't just shoot buildings. Look out for the varied characters you'll find in cities that give them their distinctive atmosphere.

• Shadows. Narrow streets can remain in deep shadow for much of the day.

TIPS

• Shoot early in the morning and around the middle of the day to get dramatic contrasting scenes – even in the same locations.

• Shoot at twilight. Cities become transformed in the evening as street lights and neon signs come into their own. Your smartphone's camera will give better results when there is still a little colour in the sky, rather than when it is very dark.

• Check that photography is allowed. In some countries it can be illegal to photograph government buildings or military installations.

• Take care with your safety. Most cities are safe to wander around but don't tempt fate. Always check (with a hotel reception, for example) when exploring somewhere new.

HOW DID YOU SHOOT THAT?

For the photo on the right, the smartphone was supported on a convenient wall (at the Palias de Chaillot) to reduce the chance of camera shake. The rich, deep blue of the sky you get between 30 minutes and an hour after sunset provided a bold and colourful backdrop. Focus was set to the Eiffel Tower which, by touching the phone's LCD screen (iPhone 5), also adjusts the exposure to best show the tower.

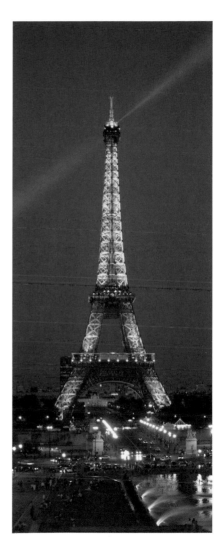

Eiffel Tower: Shoot at twilight for more colourful results than after dark. Smartphone cameras will give better-exposed photos around this time too.

VARIATIONS ON THE THEME:
URBAN LANDSCAPES

Venice and Burano: Venice is one of those locations where it's hard to put your smartphone camera down. There's a new photo opportunity around every corner. For this shot of a motor launch speeding down the Grand Canal a 'warmth' effect has been added (using PhotoToaster) that gives the scene the appearance of a heady 1960s summer. Note too how the scene has been framed with the motor launch to the left, with empty space in front, the ideal composition for this type of subject.

The colour of the cottages and homes on the neighbouring island of Burano are so bright that little modification - if any - is necessary. Some photos are just bright and colourful on their own. Know when not to apply effects - that can be as important as knowing what and when to apply them.

River Thames: Where it runs through London, the River Thames has undergone something of a renaissance over the past couple of decades, with new buildings appearing and older, historic ones getting something of a facelift.

Here a view west has been given a 50% application of an HDR effect (using an app, rather than when shooting) which helps lift the shadows cast by a midday spring sun. The saturation has also been increased by 15% to give the image a bit more of a punch and to emphasize the colours in the landscape that are normally more subdued.

URBAN ART

CAMERA ✶ ✶ ✶ ✶ ✶
CREATIVE ✶ ✶ ✶ ✶ ✶

Whether it's a backlash against lacklustre architecture or a desire to be expressive on a large scale, urban art has never been so pervasive. Urban art? Anything from authorized landmark artworks to something a little more subversive and controversial – graffiti. Whatever your views on such art it's undoubtedly a great subject for photography.

LOOK OUT FOR

• How the artworks sit in the cityscape. Do they harmonize or conflict with the surroundings? Try and capture the settings as much as the art itself.

• Street art festivals. Increasingly popular, these let you see the artists at work on their urban artworks. You might even get them to pose for you!

• Illuminated works. Some of the more prominent official artworks take on a different feel at night when they are illuminated. Experiment with your smartphone camera to see how effective it is at recording the night colours.

• The way people interact with the art. Look for puzzled expressions, curious expressions or even the disdain some people show for graffiti.

• Art trails. Trails of specially commissioned character artworks dotted around city centres (see right).

TIPS

• As with general urban photography, take care for your safety when shooting – often the most exciting graffiti tends to be found in some of the more colourful parts of town.

• Get up close to artworks for frame-filling impact. Small details of larger artworks can produce strong, graphic images.

• Conversely, shoot public art from a distance to show how it sits among the surrounding buildings.

HOW DID YOU SHOOT THAT?

The See No Evil event is an annual festival of international street art held in Bristol, UK, just about every year. Whole buildings in the centre of the city are transformed and the scale of the artworks can be hard to appreciate. For the shot below to work, a support vehicle has been included in the scene to give the photo a sense of scale. The strength of this image is in the strong primary colours – so, apart from slightly adjusting the brightness and contrast, the shot is (virtually) as delivered by the smartphone.

Gromit: Art trails are a great way to explore a city and get some great photos, and for organizers to raise money for good causes. Here's the 2013 Gromit Trail, featuring the popular animated character.

'See No Evil': For large expanses of colour like this select a mid-tone to focus on; this will tie the exposure to this point too, which should ensure the best overall exposure.

VARIATIONS ON THE THEME:
URBAN ART

Graffiti (below): Though opinion remains as strongly divided as ever as to whether graffiti constitutes legitimate art or simply defaces buildings, there's no denying this rather dull concrete and steel walkway has been enhanced by the inclusion of some street art (I am making a subtle distinction here between street art and the more ad hoc graffiti).

Rather than fill the frame with the art itself, standing back allows us to include some of the environment so it's clear what the setting is. A modest (35%) amount of HDR effect has been used to brighten the surrounding pavement and pillars to give a more even result.

Public art (opposite): I have to admit not knowing much about this piece of public art (and there was no indication nearby) but for maximum effect I got in really close so the artwork, while dominating the shot, is seen with some of the surrounding office blocks.

Shooting in bright light means that the whole scene – from the nearby parts of the creation through to the lightly clouded sky – are sharp. A small amount of sharpening was applied (to overcome some image softness) and also the saturation was increased to make the colours more vibrant.

SHOOTING ACTION
AND FAST-MOVING OBJECTS

Many of us love fast-moving action, whether it's a sports game, a thrill ride at a theme park or anything that sets the adrenaline rushing. Unlike the other genres of photography we've looked at so far, action photos demand a slightly different skillset as we have less time to think. Yet for a great shot we still need to be mindful of the rules of composition. So, how do you reconcile considered, planned shooting with necessary urgency?

It's a tough skill to master, but the beauty of smartphone cameras – like all digital cameras – is that it allows us to shoot lots, increasing the likelihood of the perfect shot. Okay, so there's a bit of luck involved – but isn't that often the way with photography? The difference between a winning shot and a great one is often tiny.

LOOK OUT FOR

• Shutter lag. Make sure you follow a fast-moving subject through the point of pressing the shutter and beyond. That way if the shutter takes a bit longer than you expected to grab the shot, you'll still get the result you were anticipating.

• Split-second changes. The more you shoot, the more likely you'll get a perfect shot. If your smartphone camera lets you shoot a burst of shots experiment with this mode as things move fast – literally and figuratively – in action photography.

• Camera shake. Getting close on the action in a sports game, for example, from the grandstand or touch line can involve using your smartphone camera's zoom to its full. That can lead to camera shake so make sure you hold your camera as firmly as possible when shooting.

• Creative blurring opportunities. You can get some interesting effects by bucking the normal advice – of panning the smartphone camera to follow a moving object – by keeping the camera dead still and letting the subjects blur.

• Dangerous situations. A surprising number of people have been injured or worse when, carried away with their photography, they have strayed too close to fast-moving vehicles or event participants.

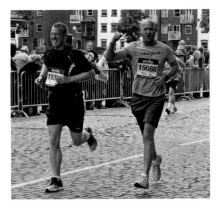

- Use creative apps to enhance or modify blurring – perfect if you want to exaggerate the sense of speed or motion.

- If you can, pre-focus on the subjects. This will cut down on the time it takes the camera mechanism to focus – giving you less shutter lag. You can get really sharp results – using pre-focus – if you shoot subjects moving towards or away from the smartphone.

- Crop your images to get a better-composed result – for example to create a Rule of Thirds composition – or to place a fast-moving object so that it's moving into the frame rather than centrally or heading out of the frame.

Marathon runners: This grabbed shot of marathon runners excitedly getting close to the finish wasn't originally well composed but a bit of judicious cropping using the smartphone's Photos crop tool produces an almost classic Rule of Thirds composition. A bright day ensured a sharp result but the smartphone was still panned to follow the runners.

HOW DID YOU SHOOT THAT?

The shot of a motorcyclist on a track day breaks some of the conventional rules of photography: we don't see him face on, but rather have a back view. But in this case, it works. To ensure the biker – and his bike – were pin sharp the camera was pre-focused on the roadway and the shutter release pressed just as he entered the frame (to account for shutter lag).

The auto enhance tool was used to improve brightness and contrast (see page 164) and then saturation increased. To give more drama and focus attention on the bike a Tilt/Shift effect was used to exaggerate depth of field.

Track day: Shoot a fast-moving subject as it moves towards or away from the camera and – if you pre-focus – results can be very sharp indeed. Plus with less lateral movement you'll have (slightly) more time to compose.

VARIATIONS ON THE THEME:
ACTION

The sporting spirit: When shooting a sporting event don't shoot just the competitors and use maximum zoom for every shot. Capture the atmosphere of an event with some wider shots and even some of eager spectators. You can then combine these with the zoom shots of the action. The sport here? Goal ball, a game very loosely based on handball for those with visual impairments.

Underground train: Holding your smartphone steady and letting the subject move leads to some slightly surreal and, with the right subject – colourful results. The low light levels in an underground rail station meant the exposure would be rather long so, by bracing the smartphone against a pillar to keep it steady, the result was a blurred train – giving the impression of greater speed than was actually the case.

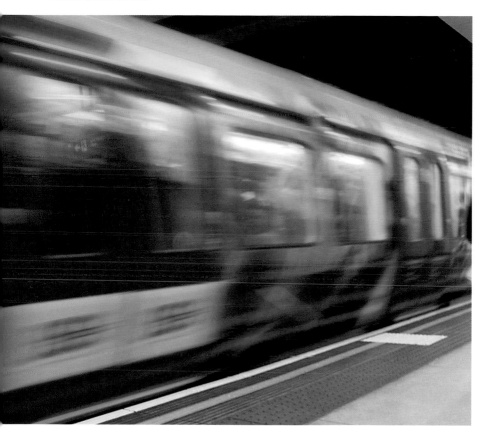

NIGHT AND LOW LIGHT PHOTOGRAPHY

CAMERA ✳ ✳ ✳
CREATIVE ✳ ✳ ✳ ✳

All photographers tend to use their cameras or smartphone cameras when the days are bright. That's natural enough; it's when we're up and about doing things. When the day draws to a close many tend to put away their cameras in the mistaken belief that there's either nothing to shoot or our smartphone cameras just can't hack it in poor light.

Neither of those is true. There are plenty of things to shoot as day turns to evening and then turns to night. And though it was fair to say that not too long ago the night performance of many smartphone cameras was a touch lacklustre, now they can hold their own.

LOOK OUT FOR

• Rich colour. Twilight skies often appear to have a touch of colour but shoot them with your smartphone camera and you may well find the colours richer and deeper – even before you start applying any apps. Blame your eyes for that – they just don't perceive colour that well at low light levels.

• Long exposures. Low light levels mean longer exposures. And that means camera shake. Arm yourself with a mini tripod or support when shooting at night. Or do what I do and carry a blob of that tacky stuff you use for attaching posters to walls. Perfect for holding your

Hidden colour: The exposure for this shot of Christmas Illuminations was biased by their brightness. Applying an HDR effect afterwards reveals the blue sky and foreground details that were hidden in the original.

camera steady on any convenient support.

• Grain. Well, actually noise. When light levels are low the circuitry in your camera can struggle to get an image and that produces digital noise – rather like grain in old photos. Rather than regard it as a problem, treat it as an opportunity to add gritty realism to those late-night images.

TIPS

• Use a self-timer. Your camera – or an accessory app – will have a self-timer that will automatically take a shot five, ten or more seconds after pressing the shutter release. Designed for letting you get in on the picture, the self-timer is also a great way to avoid camera shake when pressing the shutter release. Pressing the release on the screen, no matter how gently, can move your camera momentarily and result in a blurred image.

• Look out for camera apps that have a night mode. Typically these allow longer exposures and some will let you also fire the flash to illuminate foreground subjects – ideal for taking portraits of people in front of a night cityscape.

• Try underexposing evening shots. If your camera app permits, try underexposing (slightly) your shots of low light subjects such as sunsets. This will help improve colour saturation in the scene and require less post processing of your images.

Enhanced colour: underexpose your shots to enhance the colour.

HOW DID YOU SHOOT THAT?

Here's an interesting scene. A colourful sunset seen though the window at an equally colourful shopping mall. Unfortunately a straight shot wouldn't work: the light levels in the sunset were much higher than those of the interior.

So, the photo was exposed for the sky. In fact it was slightly underexposed to ensure that the colours were as rich as they could be. This inevitably left the foreground interior rather dark. To brighten these and reveal the hidden colours an exposure-correcting app was used to lighten the shadows. Finally the saturation was raised slightly to fully restore the colour in the interior.

VARIATIONS ON THE THEME:
NIGHT AND LOW LIGHT

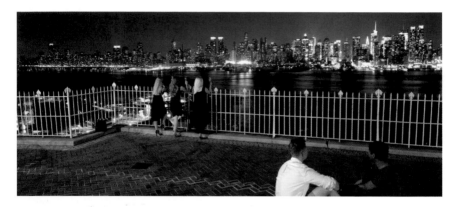

The city at night (above): The problem with many night scenes is the wide variety of light levels and the different light sources. This used to confuse cameras and deliver images with strong – and often conflicting – colour casts. Now smartphone cameras are more adept at accommodating such lighting so impressive shots like this are – comparatively – easy to shoot. (Courtesy Nokia)

Grit (left): Shots that are particularly dark, or those you try to over-brighten, can get grainy. Use this to instil a sense of mystery or ruggedness to a scene.

Art installation (opposite): To capture this art installation comprising hundreds of LED lights required a comparatively long exposure – so the smartphone was switched to self-timer and balanced on a fence post. The colour saturation was then boosted a touch to compensate for those brighter parts of the scene that were a little washed out.

STILL LIFE

CAMERA ✱ ✱ ✱ ✱
CREATIVE ✱ ✱ ✱ ✱ ✱

Still life is the most sedate of photographic genres. When shooting action we have no control over either the subject or the situations and the photographer is left to make the best of this constrained situation. Still life photography, conversely, allows complete control over the subject and the environment and timing is no longer a consideration.

The leisurely nature has led many photographers to treat it with a little disdain, but I think that's wrong. Exercising such a level of control helps improve our image crafting skills, which not only produces great still life images but carries over into other subjects too.

LOOK OUT FOR

• Unusual collections. When you're out and about, look out for unusual collections of objects that could make the perfect subject for photos. Bric-a-brac stores are great for picking up props to supplement those you have at home.

• Clichés. Bowls of fruit and Van Gogh-esque vases of flowers are the staple of many still life photographers – as are old shoes. Don't give in to convention and explore anything and everything you may find around the home.

• Distracting backgrounds. As you're shooting at home it's easy to become blasé about the background. Avoid distracting wallpaper, for example. Or use large sheets of paper or card as a backdrop.

TIPS

• Experiment with lighting. Once you've found a great subject and composition try different lighting schemes. Desk lights work particularly well and allow you to point the light directly at parts of the scene or bounce it from the ceiling or reflective surface to provide softer illumination.

• Try black and white. Still life shots can often be about textures as much as colour, so try converting your colour images to black and white. As we discuss on page 172, experiment with different filters to produce different effects.

• Boost the texture: Applying an HDR effect can really enhance the texture, particularly of

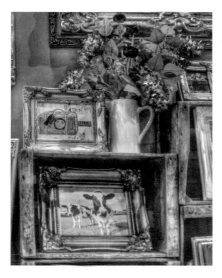

rustic subjects, giving a grittier appearance.

• Soften the texture. Conversely, for softer, more romantic subjects, you may want to apply a degree of soft focus to reduce some of the hard details in subjects, giving them a more dreamy feel.

HOW DID YOU SHOOT THAT?

The traditional approach to still life photography tends to use dark settings and very directional light. For this shot I wanted to buck that trend with something brighter and more frivolous.

The three pots of flowers were arranged on a table outdoors, under an overcast sky (avoiding harsh shadows). Getting in close increased the depth of field and blurred the background slightly. The degree of blurring was increased by using a Centre Focus app (a bit of a blunt tool, unless used carefully), which also allowed me to brighten the central, in-focus region. Finally a very modest soft focus effect was applied – just sufficient to help mask some of the finer detail and add to the overall lightness of the scene.

Window display (top): It's a bit of a cheat but sometimes you can find excellent still life displays in shop windows. Okay, so you don't have ultimate control in the sense that you do from your own still life, but it's a great way to get some impromptu images and practice. Apply a filter effect, as here, or boost the colour saturation to pep up the scene.

Summer flowers: Still lives need not be dark or drab; bright colours and bright lighting are equally suitable when used with the appropriate subjects.

VARIATIONS ON THE THEME:
STILL LIFE

Low-key portraits: Portraits? As a still life? That does sound somewhat incongruous but when tackling a more formal style of portraiture many of the rules of still life can be applied with very effective results.

Here the portrait subjects have been positioned in a dimly lit room and are lit only by the light from a window. By focusing on and selecting an exposure from one of the faces, the background is made even darker. After shooting, using the built-in adjustment tools the contrast was increased slightly (by a modest 5 to 10%) and the brightness reduced by a similar effect to produce an image that photographers call 'low key', where the dark tones predominate.

Desk paraphernalia: One of the beauties of still life photography is that you can work with the most mundane of subjects. Here the photographer had to go no further than a desk, arranging the casual objects found there into a photogenic collection.

SHOOTING A THEME

CAMERA ✳ ✳ ✳ ✳
CREATIVE ✳ ✳ ✳ ✳ ✳

There's no doubt that the more photos we take, the better our skills become and the more able we are to see the world. It can, though, sometimes be difficult to focus on a particular genre of photography. The opportunities – no matter how hard you look – just aren't there.

So when you feel utterly starved of motivation what can you do? Shoot a theme! Head off with your camera and, with an idea of a theme firmly in your head, get shooting. What do we mean by a theme? It could be anything from the obvious and the everyday ('cars', 'trees', 'shadows') to something that demands a little more consideration and creative interpretation ('blue', 'five', the letter 'A'). The only rules are that you should stick to the brief and be creative!

LOOK OUT FOR

• New ideas. Find an image you like and use it as the basis of your theme.

• Photo contests. 'Shoot a theme' is a popular category for online (and some magazine) photo contests. Start by exploring the way entrants interpret a theme – particularly more off-the-wall interpretations – and build your collection of shots ready for the next competition!

• Theme subjects that push the boundaries of your skills.

TIPS

• Have two or three themes in your head so that you can quickly switch between opportunities.

• If you're shooting those everyday subjects, don't just go for the straight shot; look for – literally – a more imaginative angle.

• Keep reviewing your images and examine how your skills – particularly the creative ones – improve with time and as you learn to see the subject of your theme in more inventive ways.

WHY DID YOU SHOOT THOSE?

The theme here was 'spirals'. They are not that common in the environment – but then the idea of shooting a theme is to set yourself a challenge. And the closer you look, the more you'll find. The seeds of a sunflower, shell of a snail and so on.

So what did I find? Well, A lighthouse staircase, the core of a succulent plant, a labyrinth and some stained glass. Okay, the labyrinth – on an underground train station wall – is not a true spiral, but there's no need to be pedantic. Shooting themes should be fun as well as instructive.

'Spirals': When you shoot to a theme you can aim to get a collection of shots in a single day in a single location or wider afield; this was one of those projects that took a little longer, constantly added to through the year.

VARIATIONS ON THE THEME:
THEMES

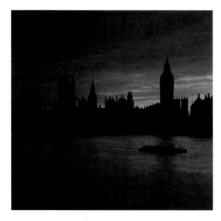

One image, many photos: Photography – and smartphone photography particularly – can be all-consuming. So as well as getting you out and about thinking laterally about what fits the brief of your theme, you can also try creating variations on just one of your images using different apps and effects.

It can be an entertaining way to spend your time on your daily commute. It's also a great way to explore your apps and discover new ones. Above, original image and Dynamic Light's Urban Art effect.

CONCERTS, THEATRE AND FESTIVALS

CAMERA ✳ ✳ ✳
CREATIVE ✳ ✳ ✳ ✳ ✳

Watch a popular concert or festival stage on TV and, when the camera swings to the audience, what do you see? Often it's a sea of darkness peppered with bright flashes as the audience turn their smartphone cameras on the performers. Ultimately those shots will disappoint. For a start the flash just won't be sufficient to light a relatively distant scene. Then the light on the stage is likely to be so variable that the camera won't accurately record it.

But all is not lost. There are still ways you can get some memorable shots. You just need to be aware of your smartphone's capabilities.

LOOK OUT FOR

• Extreme lighting. Lighting levels can vary enormously, taking them outside the range that your smartphone camera can accommodate. And that lighting can be – for dramatic purposes – strongly coloured, playing havoc with your camera's white balance settings. Use a camera app that will let you expose for a particular element in the scene.

• Sideshows and acts. Particularly if you are at a music festival, there's a lot more going on besides what's on the main stage. Many side shows or other displays are ideal for some great atmospheric shots.

• Bright set pieces. Whether it's a concert or a theatrical performance, the big, set pieces are

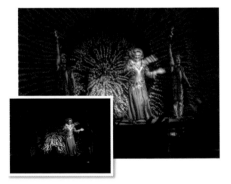

Theatre: Casual shots from the auditorium can be challenging when light levels are uneven. Your smartphone camera will average out light readings and give an unsatisfactory result. All is not lost, though. Use an app that lets you even out the exposure or apply an HDR effect. This could help you rescue those parts of the scene – usually the key ones – that are overbright. Use a sharpening app to reduce the level of unsharpness.

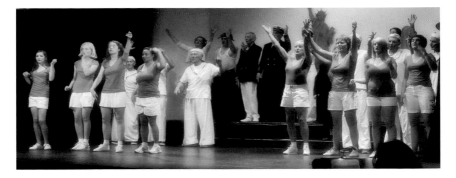

often the more brightly lit and provide a great photo opportunity without needing to zoom in too much.

- White balance. Deliberately skewed lighting colours can confuse smartphone cameras, which don't expect the whole scene to be red or blue, say. You may have to use an app later to correct large differences in colour.

Group shots: It's difficult – if not impossible – to get close enough to the stage to shoot individual characters, so go for group shots and chorus lines.

TIPS

- Use a support to ensure sharp results even if the exposures are tending towards the long. A balcony rail or a seat back can be pressed into use.

- If your camera has, or you can download, the respective app, activate the vibration/shake reduction: it can make the difference between a sharp and unsharp image.

- Turn off the flash. It won't do the job you were expecting and you're likely to annoy both the cast or performers and the audience.

HOW DID YOU SHOOT THAT?

This group shot is the type of theatrical shot that is more likely to be successful when using your smartphone camera. I waited until there was a scene where the stage was brightly lit, and also one where there was a lot going on. I didn't – indeed couldn't – zoom in successfully to capture individual expressions.

Even though the stage was well lit, there was still some shading on some of the characters that increased contrast. Using the Ambience effect helped brighten those shadows and give a more even lighting effect.

I did then notice that there was a slight graininess in the image so I applied a very mild amount of soft focus (using the Soft Focus app) to mask this, without making the whole image unduly soft.

VARIATIONS ON THE THEME:
CONCERTS, THEATRE AND FESTIVALS

Atmosphere (left): There's more to a festival than the music performances. Look around for the colourful and atmospheric – shooting these will bring back great memories of the event too. These festival flags were an easy shot – zooming in to focus attention and then, afterwards, boosting the colour saturation.

Look for the unusual (right): You'll find plenty that's weird, wonderful and photogenic at a festival. Guidelines for shooting them would be complex so it's better to just give it a go. If it doesn't work try something else. Here the bold primary colours from within a Colourscape inflatable catch these audience members enjoying – and photographing – a performance.

Auxiliary lens (below): To get close to the action, and get great results, you could resort to an accessory lens. Here a Sony QX10 lens lets us get in close and still get sharp noise-free images (see page 232).

INTERIORS AND TIGHT SPACES

Given what a great all-rounder the smartphone camera is, it can be frustrating to find that when it comes to shooting interiors the lens just can't get you the wide shots to do justice to cramped spaces.

Don't despair though. If you're in one of those once-in-a-lifetime locations you can still capture the grandest of interiors. A wide-angle lens adaptor gives you the power of a wide-angle lens. Panoramic modes – normally reserved for sweeping landscapes – can work too, if you make allowance for the possibility of distortion. And there are clever apps like Photosynth that can help you capture the most extreme of interiors.

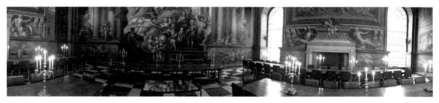

Interior panoramas: Panoramic apps are normally designed for capturing landscapes so in confined spaces can produce distorted images such as this.

LOOK OUT FOR

• High contrasts. When you shoot indoors there can be a high contrast between the interior space and the bright light streaming in through windows. These can skew your exposure to make the interior too dark.

• Image distortion. Try to keep your smartphone level when shooting interiors. If you tilt up or down you can have distortion. If you have to tilt the camera, do so more deliberately for really dramatic effects, such as emphasizing height. And never tilt the camera if you're shooting a panorama.

• Mixed lighting. Cameras are honest in the way they represent a scene. If there are different lighting types in an interior they can produce colour casts. Fix these later using an enhancing app or selective adjustment app.

• Photography bans. Many public interior spaces, whether for security or religious reasons, limit photography. Sadly that ban also extends to smartphone cameras – you may grab one shot but you're likely to be asked to leave before you can get another. Especially if a burst of flash betrays your actions.

TIPS

• If you find you're shooting – or wanting to shoot – a lot of interior spaces it's worth investing in a wide-angle lens adaptor. We have more to say about lens adaptors from page 228.

• Shoot at dusk if there's a lot of daylight in the scene: this can give you a better balance between outside and inside lighting

• Cluttered interiors: if you've any control over the interior spaces you're shooting (or shooting in) have a little tidy up before getting your shots. Five minutes clearing up will produce a less distracting image.

• And while you're at it... move objects around if you feel it will help with the composition. If you've lots of empty space in the foreground bring something forward to provide interest in the same way that you might compose a wide-angle landscape shot.

The Painted Hall: Some interiors defy hyperbole and it's disappointing when a smartphone camera alone can't adequately accommodate the view. So don't miss the opportunity – add a tiny wide-angle adaptor to guarantee a great shot (the insert shows the standard – and unfiltered – image from an iPhone 5 camera).

HOW DID YOU SHOOT THAT?

The breathtaking Painted Hall of the Old Royal Naval College, Greenwich is impossible to capture in a single shot. It's also difficult to represent the scale of the hall. For this shot I had to resort to using a wide-angle adaptor clipped on to an iPhone 5. That still failed to capture the scene as I wanted it. Cue crouching on the ground to squeeze every degree in the field of view.

Despite the generally dark painted panels of the hall, the building is well illuminated with many tall windows facing south. Bright sunlight would have been ruinous to the picture, casting bright pools of light on the wall. I waited until the sun had passed to the far south-west to avoid this. The result was a little blue colour cast from the windows (from the clear blue sky light) but it was corrected with a warming effect app. This had the initially unintended benefit of giving an enhancing warming effect to the paintings.

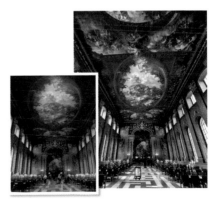

VARIATIONS ON THE THEME:
INTERIORS

Photosynth (above): Microsoft's Photosynth app offers a clever variation on the theme of the panorama. Rather than scanning the horizon with your camera to build up a panorama, you simply click away, building up an image both horizontally and vertically.

Once you've grabbed all the shots you want, the app will stitch together all the images and produce amazing ultra-wide images.

Tight interiors (opposite): Make the most of interior space by standing well back. Keep the camera level to ensure you don't introduce distortions. Where light levels vary, such as here, apply a degree (50% or so) of HDR to even out the lighting levels. You may need then to adjust the saturation levels to restore some of the colour to the brightened shadow areas.

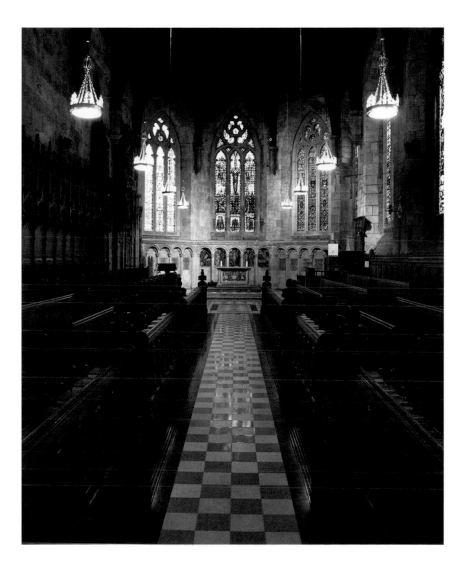

USING
APPS

So far in this book we've looked at ways to shoot great photos and how to develop some key photographic skills. Example images along the way have illustrated ideas and techniques and often app effects have been used to enhance or modify those images.

Now let's take a more structured approach to what manipulations and effects we can gain from using apps and how these can help us craft some compelling images.

I think we all have the urge, when first discovering what apps can do, to apply them indiscriminately to our images. Sometimes the result is successful, but often it is less so. When image editing applications for computers first appeared, keen digital photographers were only too eager to apply the most extreme of filter effects and submit the resulting images for critical acclaim.

Such acclaim rarely came, as those judging the photos pointed out that the idea of applying a filter effect was to improve an already-good photo, rather than just apply a radical transformation to a mediocre shot.

So it is with smartphone apps. As we gain knowledge about what an app can do – and more importantly what it can't – then we need to become a little more circumspect. It's so important to realize that adding an effect doesn't necessarily improve an image. And there will be occasions – numerous I hope – when you decide that the photo you've shot doesn't need to be improved and stands on its own merits.

WHICH
APP?

When we look at all the image editing and manipulating apps available for smartphones – and there are an awful lot of them – they quickly seem to align themselves into two broad camps.

CORRECTIVE APPS

In the first we have what we might call the corrective apps. These are designed to fix shortcomings in the original photo, whether down to the quality of the original image or shortcomings due to the photographer. Many of the features in the app suites we looked at earlier fit in this category.

Smartphone cameras can be likened to what photographers call 'point and shoot' cameras. Like these, your smartphone camera is designed for simplicity so you really can grab your phone, select camera and get a shot, without any unnecessary messing around with controls.

That easy-use approach doesn't compromise the quality of your photos. In general they'll be pretty good. But sometimes things won't be perfect. The exposure might not be right or the contrast could be a bit low, leading to images that are a bit flat. Corrective apps help you put things right and produce a shot that looks more as you recall it.

Also in this group we have all those apps and features that help you compose the shot better, letting you trim it to enhance the composition or correct for bad camera work – straightening crooked horizons, for example.

CREATIVE APPS

In the second camp are the more creative apps. These are designed for transforming your best photos whether subtly – lifting dark shadows a little, or giving the colour a modest boost – or more profoundly.

Many creative app effects are designed to give the desired effect simply, often with just a touch

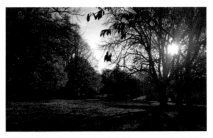

Autumn late afternoon: Too bright a sun results in this scene becoming rather dark.

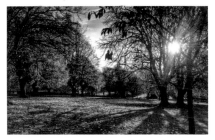

Auto enhance: The auto enhance feature starts to reveal the hidden potential – and the vibrant colours – in the shot.

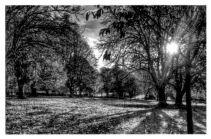

The finish: An HDR effect finally releases all the colour and gradation that was latent in the original shot, producing an image that better reflects what the photographer saw when shooting.

of a button or stroke of the smartphone's screen: choose your image, slap on the effect and stand back and admire. This is great when you want to edit an image quickly and share your results instantly. You do, however, need to be a little considered as some effects can be rather intense.

Therefore, when you're examining new apps to add to your phone, look for those that give you additional control so you can tone down specific features of the effect.

RELEASING THE POTENTIAL OF AN APP

It can come as a pleasant surprise to those new to smartphone photography to discover how a photo can be enhanced in just a couple of steps. This shot of an autumnal parkland is dark and unappealing. The bright sun in the shot has skewed the exposure so that all the rest of the scene is essentially underexposed.

Using the auto enhance feature (second photo) on the smartphone camera does a commendable job, evening out the brightness and contrast and lifting the colours a little from the mire.

Apply an HDR effect – on an intermediate setting, say 50% – and the photo really delivers. Neither of the effects applied has added anything to the photo as such, they have merely helped make them more prominent.

CROPPING AND TRIMMING YOUR PHOTOS

Impact is important in creating powerful images. I've already mentioned how important it is to get subjects as large as possible in your photos for maximum impact – and how the rules of composition can help with the placement.

Often, though, in real-world situations, we can't get close and, try as we might, we can't quite frame shots to their best compositional advantage. All is not lost, however. By trimming away superfluous parts of an image we can crop it down to a format where the subject is more prominent and the composition enhanced. This is where the cropping tools – called trimming tools on some smartphones and in some apps – come to our aid.

Many apps feature cropping tools but often you'll also find one in the editing tools of your basic Photos app.

CROPPING YOUR IMAGE

Once you've selected the cropping tool it's simple to crop the image. You just move the sides of your photo inwards one by one until you achieve the best results. You don't have to adjust every side: it may be sufficient to move just a couple if you want to retain the original image format.

Neither, though, do you have to retain the original format. You may choose to crop an image into a square, or perhaps cut away a boring sky and foreground in a shot to leave a panoramic view.

Don't crop too aggressively. When you crop an image, its size – and resolution – is diminished, meaning you'll not be able to enlarge the trimmed image as much as the original. Note too that some cropping apps feature presets. These will automatically select, for example, a square crop, or crops that will produce an image of the right proportions to print using common inkjet printer paper sizes.

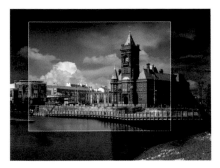

The picture within: Often a so-so image can be improved by trimming away uninteresting areas or those with distracting objects, or simply to improve the composition.

STRAIGHTENING IMAGES

Unless you're doing so for creative effect (when the look should be obvious) horizontal lines (such as the horizon) or verticals should not be wonky. Be assured that no matter how good a photo otherwise, a tilting horizon will be all people see.

Use features such as Straighten in Snapseed to ensure those verticals or horizontals are spot-on.

Non-standard formats: The cropping tool lets you crop images into any format that might be suggested by your subject. Don't forget you can manipulate the cropping lines as much as you like before committing them to the image.

BRIGHTNESS
AND CONTRAST

Now you've got your shot into shape – literally if you've used the cropping tool – it's time to look to the image quality. Let's start by looking at the brightness and contrast. Getting these right will help us best appreciate your shot and determine what else, if anything, needs attention.

Often there's little adjustment needed: your camera will have made a pretty good job of getting the levels right. But, now and again, the exposure can be a little off what you might consider perfect. That's probably because you've focused on a specific subject in a shot and the exposure too has been calculated for that point – which is not necessarily the most appropriate for the scene as a whole.

You may also need to modify the brightness if you've shot a dark subject – the auto exposure system will makes such shots brighter than they should be – or, conversely, a bright subject.

ADJUSTING BRIGHTNESS AND CONTRAST

Sorting out the brightness levels, though, is a simple matter. In the basic editing tools for your Photos app you'll find sliders that let you adjust both brightness and contrast. How far

ONE-HIT WONDER?

Just about all smartphone cameras have an auto enhance feature, usually under the editing controls in the Photos app. Select this and the software will analyse the photo and determine the best brightness, contrast and colour saturation levels. All sorted in one go.

Does it work? For the most part yes, but don't use it to correct every shot – it's a blunt-edged tool that will fix photos with a normal range of brightness and contrast but struggle to do so where you've been a bit more creative in your photography.

Floral sculpture: The predominance of dark tones in this scene resulted in the shot being overexposed. Using the brightness control the image could be restored to its original look, with the contrast being adjusted to give the best balance of tones.

do you go? It's a matter of judgement. If the image looks good to you, then it probably is. If it looked better before you made any adjustments, then the camera probably made a good job of getting the settings right in the first place.

If you do make adjustments check that you don't end up with too much contrast, which can lead to bright, featureless areas – such as skies – and dark, equally featureless shadow areas.

IMAGE TUNING

Adjusting the brightness and contrast of an image is a quick way to put right exposure problems and, if I can be slightly controversial, a traditional approach. We can now access more comprehensive tools that can breathe even more life into our shots.

FEATURED APP: SNAPSEED (IOS) [ANDROID]

TUNE IMAGE

One of my favourites for enlivening images is Tune Image, one of the options in the Snapseed app. At first this can seem a bit daunting as it boasts several controls:

• Brightness
• Ambience
• Contrast
• Saturation
• Shadows
• Warmth

Brightness and Contrast are familiar, as is Saturation. But Ambience? Shadows? Warmth?

Ambience: The intriguingly named Ambience control is perfect for shots with a wide range of bright and dark areas that are difficult to display successfully otherwise. It often reveals details in those dark and bright areas that were not clear in the original shot.

AMBIENCE

Snapseed describe Ambience as 'a special type of contrast that controls the balance of light in a photo' but I tend to think of it as an 'HDR lite'. Like HDR apps, it gently darkens the brightest areas whilst lightening the dark, reducing the dynamic range in the shot for a more pleasing – and often more colourful – result, but it does so in a much more subtle way.

SHADOWS

If dark shadows are a prominent element in your photos they can be featureless and distract from the main subject of the shot. Using the Shadows control will brighten deep shadows without affecting the midtones and brighter areas.

WARMTH

Photos shot under bright blue skies or overcast conditions can feel a little cold as the colours are skewed slightly towards the blue end of the spectrum. Using the warmth control you can correct for this or, if the original shot is already too warm, reduce those tones to produce something more neutral.

WHY SNAPSEED?

You might have noticed that Google+'s Snapseed app has been used a number of times through this book. That's not because I have any personal interest in it but because, first of all, it's comprehensive. You can make all manner of corrective and creative changes with it. Second, it's available for iOS smartphones, Android smartphones and, via Google+ on your desktop, your computer too. It's also a free application!

Snapseed: Multiple options and controls make this a very versatile app.

SHARPENING

When image editing applications like Photoshop first burst on the scene, many lauded them and claimed they had almost magical powers. 'Even if your photos are blurred', they said, 'it's no problem – you can make them sharp using this incredible software.'

Such promises were a little off the mark: it was – and is – impossible to restore sharpness to a blurred image. But what those applications could do – and what their mobile siblings can also do – is increase the perception of sharpness in an image.

ADDING SHARPNESS

Try as we might, not all our photos will be pin sharp. Okay, on a bright summer's day the exposure time will be so brief that just about any shot you take will be in perfect focus. Introduce just a modest amount of camera shake, though, through holding the camera insecurely, and the photo loses that critical sharpness. The problem will only grow as light levels fall. It is this modest lack of critical sharpness in an image that we can attend to.

Sharpening apps include Adobe Photoshop Express and Snapseed. In Photoshop Express you can use a slider to add the precise amount of sharpening; the image you're working on will automatically zoom in so that you can see the degree of sharpening as it is applied. Don't be inclined to overdo it – and if your photos are seriously blurred don't even try to fix them in this way – it just won't work.

FEATURED APP: ADOBE PHOTOSHOP EXPRESS [IOS] [ANDROID]

TAKING IT TOO FAR

It can be tempting when you see what a difference the application of a sharpening effect makes to take it further, applying it again. That way you'll get twice the sharpening effect, right? Sadly no. Because the sharpening effect is illusory rather than actual, repeating the action a second or

even third time doesn't improve the image at all, rather it degrades it.

Look at the example below. Applying a modest amount of sharpening had created a crisp image, but the photographer wanted more and applied a sharpening app a second time. Viewed close up, the image starts breaking up in to very obvious blocks. You may not see these when you view the image from a distance but what you will notice is a rather flat image without the warmth and depth of the original.

Job done (top): Applying a modest amount of sharpening restores apparent sharpness to this image that was, before treatment, slightly soft.

Sharpening tools (left): Subtlety is the key when sharpening. Use the slider provided (as here in Photoshop Express) to add a precise amount of sharpening.

Over-sharpening (below): You can have too much of a good thing. Apply too much sharpening and your image begins to degrade rather than improve.

COLOUR CORRECTION: GETTING THE RIGHT COLOURS

We mentioned earlier the inability of digital cameras – not just smartphone cameras – to accommodate the full range of brightnesses in highly contrasted scenes. The HDR technique, however, lets us squeeze a little more dynamic range in. Well, cameras aren't always the best at representing authentic colours either.

With the best of intentions, your camera will see the scene as it thinks it should be seen, adjusting the results to deliver a photo that it believes gives the best balance of colours. The good news is that, for most of the time, it gets things pretty well spot on. The inevitable bad news is that, when you're in creative mode and have a photo, say, where one colour dominates, the camera will try to average this out, often to the detriment of the scene as a whole.

CORRECTING COLOUR BALANCE

We can, though, retrospectively correct the colour. That means either putting things back the way we saw them or manipulating them so they look the way we perceived them. Common corrections that we might make include:

• Adding warmth to photos taken after dawn or before sunset

• Reducing the yellow cast often seen in night scenes

Snowfields: Snow, particularly in bright sun, can fool the colour balance settings on your camera. Left to its own devices this shot of an Icelandic landscape is unduly blue. By adding a subtle amount of warmth the result is much more natural, and more closely resembles the scene as originally perceived.

• Boosting the colour in bright sunny scenes

Depending on the app you use, you can manipulate the colour balance either by clicking on a colour corrective alternative preset (for example, 'warm' or 'cool') or using sliders to add the precise amount of correction. As with so many corrective measures, there is not a right and wrong. If your adjustments make the image look good, or improved, then that's fine. Just be a little circumspect and don't overdo things: there's a significant difference between a well-saturated image and an oversaturated, garish one!

FEATURED APP: ADOBE PHOTOSHOP EXPRESS [IOS] [ANDROID]

COLOUR CORRECTION: WHEN IT'S JUST NOT WORTH DOING

We've made the presumption here that colour authenticity is paramount. If you're going to apply some app effects to your photos then, chances are, the colours in the scene will be so compromised in the finished image that getting things right in the first place just isn't worth the hassle.

Colour fantasies: Where there is no clear frame of reference (for example sky or grass) it can be hard to get colours spot on. In a case like this Indian parasol, that hardly matters – even when using absurdly different colour balances the results look good.

BLACK AND
WHITE PHOTOS

Many photographers still prefer to shoot in black and white. Only by shooting in black and white, they will attest, can you appreciate the texture and tone in subjects. It's probably fair to say, though, that photographers who are devotees of smartphone cameras are less likely to be fans of monochrome. That's a shame, because shooting in black and white can produce some powerful results.

SHOOTING IN BLACK AND WHITE

How, though, do you shoot in black and white? There are some camera apps that will help – such as Camera Noir, which will record all images you shoot in black and white. I, however, prefer to apply a black and white effect to a photo I've already shot. Why? Because if I don't like the result I can go back to the colour original and try some alternative treatment.

Many apps, including Snapseed, offer a black and white effect option. When you first apply it to your image you'll probably be underwhelmed. Simply taking away the colour component doesn't really produce a strong image, just an image that is, well, grey. Don't worry, though. We'll get more interesting results when we select colour filters.

These filters, included in the black and white effects, emulate the use of colour filters on the camera lens. If you shot in black and white with a red filter on the camera, blue skies would become dark – even black – whereas red objects would appear virtually white. Similarly, with a green filter, foliage will take on a light hue, red objects will become darker and blue skies a mid grey.

The example here shows what happens when you put a virtual filter over the colour image using a black and white app.

The unfiltered image is rather bland, with different colours represented by broadly similar tones of grey. Apply colour filters though and the image springs to life. In this case at least, the black and white images are just as bold as the colour.

Street dancers: These bright, colourful carnival dancers make a dazzling photo when shot in full colour.

Black and white: The simple conversion to black and white treats all colours equally so elements of equal colour density – but different colours – are all rendered an identical grey colour. All impact of the shot is lost.

Green filter: When a green filter is applied (by the app software, of course) those elements with a green component are rendered brighter and other colours remain shades of grey.

Red filter: With its strong red components, the shot under a red filter is much more dramatic, with those red elements becoming bright and blue elements dark.

TONED BLACK AND WHITE PHOTOS

Some images are so bold and graphic, they can look better in black and white where the distraction of colour is shorn away. You can also create toned prints where the photo is represented in shades of a particular colour rather than shades of grey.

Sepia toning is the classic example of this: often used (or some would say overused) on historic subjects, sepia toning gives shots a distinctive amber tone. Other colours can be used, though, and you should aim for something that adds to the pictorial value of a scene.

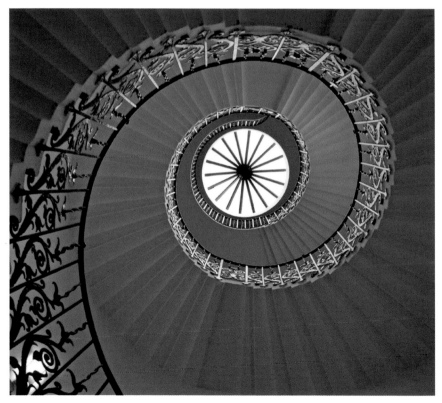

The Tulip Stairs: This spiral staircase at the Queen's House in Greenwich, London, presents a form that is graphic and already pretty monochromatic However, by converting it first to black and white and then adding a colour tint (PhotoToaster) we can create an image that enhances that bold form.

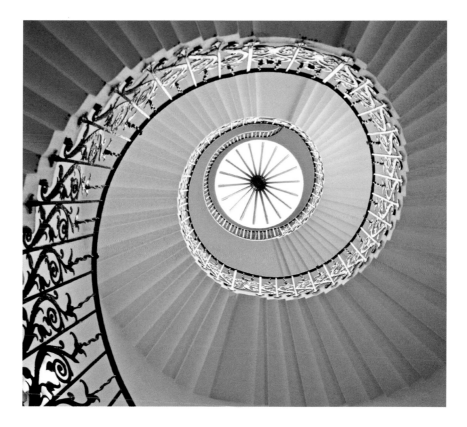

ADDING JUST
A TOUCH OF COLOUR

Steven Spielberg's *Schindler's List* was a highly memorable film for so many reasons. One particular scene that many will recall was that featuring the girl in the red coat. In a movie filmed otherwise entirely in black and white, the sparing use of just one colour removed any possible ambiguity over what might be the subject of that scene.

Spielberg's use of the emphasis colour technique may be one of the better-known examples but it was not the first nor the last: you can now use smartphone apps to recreate this selective colour approach.

Though promoted as letting you add a single colour to a scene that has otherwise been rendered in monochrome, apps such as Dash of Color will in fact let you select more than one. That makes them ideal for isolating a single person, say, in full colour – within a crowd.

SELECTING A SINGLE COLOUR

These apps work by concealing the colours in an image, showing only the black and white version. Then you can restore – by a simple touch – the colour in your chosen parts of the image.

This is easy if you have large, obvious areas of colour but less easy if the areas are fine or

irregularly shaped. Fortunately the apps will let you zoom in on sections of the image so you can be more precise with your fingertip painting. You'll also find an eraser tool – so you can wipe colour from areas where your finger has erroneously strayed – and an undo button that lets you undo your last painting act.

FEATURED APP: DASH OF COLOR [IOS] [ANDROID]

Mini (opposite): A dash of colour is perfect for drawing additional attention to a subject. Without the selective colour this could equally be a shot of a rather grand Georgian home with a car parked inconveniently outside rather than a portrait of a car with classical background.

Gromit statue (right): You need not isolate a single colour – if a subject is polychromatic as here, you can still separate it from the surroundings.

Orbit (below): The largest artwork in the UK, the ArcelorMittal Orbit is a distinct and bold red colour, just perfect for emphasizing using the selective colour technique.

CREATING A BRILLIANT ARTWORK

I often get the feeling that photographers are frustrated artists. True, we can create works of art that stand proud against any painting, drawing or pastel artwork. So why do so many photographers then transform their landscapes and portraits into pseudo oil paintings or watercolours?

I'm afraid I can't come up with an answer other than to say that, done properly, an artwork-from-photo can look very good. And the conversion can hide imperfections in the original scene – a blemish on a portrait subject's face, televisions aerials and satellite dishes on an otherwise quaint landscape – producing a more pleasing result.

Recognizing the latent artistic aspirations we may have has driven many app authors to produce apps that impart a painterly effect to our images.

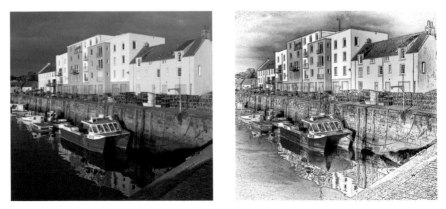

Harbour scene: Mobile Monet has been used to create a watercolour painting effect in this harbour scene. Rather than paint over the whole scene, be a little more subtle, varying the intensity of colour.

FEATURED APP: MOBILE MONET [IOS] [ANDROID]

PRODUCING A PAINTERLY EFFECT

Some painting apps are pretty basic, applying an instant transformation that will give a conventional shot the look of an oil painting, a watercolour or even a pen-and-ink drawing. Others allow you a little more creativity and let you have a little more input. One such creative – and popular – app is Mobile Monet from East Coast Pixels, creators too of the well-regarded PhotoToaster app.

Select an image in Mobile Monet and you'll see it reduced to a black and white line drawing. Now use your finger to colour in the image, following the contours of the line drawing. You'll find that your image is, to a modest degree, pressure sensitive: the harder you press, the deeper the colour.

I tend to find that with many of these 'paint on' apps, it can help to boost the colour saturation prior to using the app. This gives you a little more flexibility in your painting technique.

St Paul's: Though designed to give shots a look of grimy urban decay, I find that Snapseed's Grunge filter can give some powerful painterly effects. Here a touch of HDR and a watercolour paint effect have been applied.

GETTING REALLY CREATIVE

If you want to create something with more convincing artistic aspirations, check out the options in PC/Mac image editing apps. Designed for more subtle and detailed work, the artistic filters you'll find in just about all image manipulation applications give you much more scope to manipulate your images precisely into a more realistic artwork.

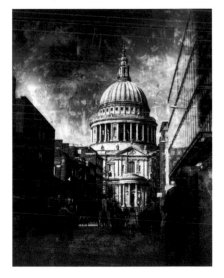

GIVING YOUR PHOTOS AN EDGE

Thanks to apps like Mobile Monet and other painting apps, you're now creating some fine art as well as some great photos. So, how do you finish them off? With a frame, of course! A good frame can really finish off your pictures, artistic or photographic, showing them off to the best advantage. Just as those cherished photographic prints you have at home look better when mounted in a good frame, so your smartphone images can look great if you give them a complementary border.

Adding a border to your images is simple – many applications feature a wide selection of borders and frames that you need only click on to apply. A bit of judgement is needed, though, to ensure that you finish off your image with a frame that balances the image rather than something that competes for attention.

FEATURED APP: PHOTOTOASTER [IOS] PHOTO STUDIO PRO [ANDROID]

CHOOSING A FRAME

When presented with such a vast array of frames as you'll find in many applications, our instinctive reaction is to go for something extreme. It's human nature and an expression of our individuality. It's the same drive that means we often choose the most fanciful (and ultimately illegible) font when creating a poster or captions on our computer.

We need to rein in this drive and start by looking at something more sober.

SIMPLE LINES

If you've a powerful image the best way to frame it can often be a simple border. It's the way that pro photographers present their images: just a simple fine line bordering the print. It can be a black line with an outer white border or, conversely (and often a more prominent solution), a fine white line with dark outer border.

Fine lines are great if you plan to print your images, but can be too fine to properly display if you only plan to view and share your images on your smartphone camera's display. In this case you can go for something a little broader – and more obvious. It still has the desired effect: finishing off your image without competing for attention with that image.

ROUGH EDGES

Fine lines or broader, these frames do tend to be a little formal. Great for serious subjects but less so for fun photos. In these cases – and if you still want something simple, go for the more informal rough-edged or brush-edged frames.

FILM EDGES

It's funny how digital images so often try to ape those from conventional cameras – as we'll see shortly. That extends to giving a neat digital image a frame that mimics those of conventional film stock. It's an interesting effect – if used sparingly.

OVER THE TOP

And then there's... frames that are completely over the top. Circular, heart shaped – you know the kind. Serious photographers baulk at the thought but, for producing the odd birthday card or a fun greeting, they arguably have their place. Apps like Photo Studio PRO have a wide selection of fun frames.

Fine line: This kind of fine line is a professional's preferred way to finish a print – but it can be a bit bland used on a fun image.

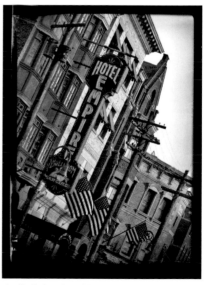

The film look: Perhaps it's the – incorrect – belief that film photography has greater gravitas than digital that makes people use film edges.

EMULATING RETRO AND TOY CAMERAS

Something odd happened in the early 2000s. In a world where the digital camera had come of age and was both an affordable and desirable option for the mass consumer market, there was something of an ironic backlash. In this increasingly digital world a small band of people were eschewing technology and reverting to film cameras. And not ordinary cameras but the quirky Lomo cameras, renowned for their iffy build quality.

That poor build quality had made the cameras something of a cult with photographers – or Lomographers as they preferred to be called – since the 1990s, exploiting the low quality lo-fi nature of the images produced. In a world where quality and megapixels – and the more the better – were the driving force in camera design, here was a genre of photography where all that was irrelevant.

Lomo LC-A: Possibly the antithesis of the smartphone camera, the Lomo LC-A is probably the most popular of the toy/retro cameras.

For many who loved the naïve results you could get with a Lomo camera (which seemed now to be manufactured in greater numbers than ever) there was a big hurdle: lack of immediacy. Once you shot photos with your Lomo camera you had to get them processed. And that meant you couldn't view them straight away. Cue a digital solution.

CREATING LOMO-STYLE PHOTOS

The characteristic of Lomo photos – and those from the similar Holga cameras – were soft focus (lenses were often made of plastic), poor alignment and film fogging (thanks to the poor light seals in the camera). Throw in a measure of vignettes: dark corners to shots from the lenses being undersized and garish contrasty images from the specially commissioned films used.

Unfortunately – as Lomographers might say – smartphone cameras boast very good lenses and have no problem with light leaks. So the photos they take are nothing like you'd get from a Lomo but it didn't take app designers long to bridge the gap and create apps that would emulate these cameras. Both on live, when shooting new images or applied to those already in your library.

FEATURED APP: RETRO CAMERA PLUS [IOS] [ANDROID], SNAPSEED RETROLUX [IOS] [ANDROID]

Also consider: Lomo All in 1 (iOS), Lomo Camera (iOS) (Android)

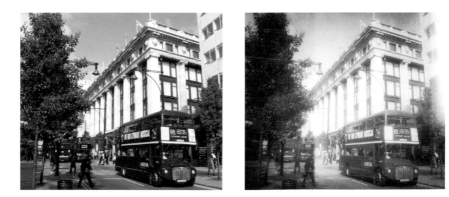

Oxford Street: This shot is possibly archetypal of the most overt Lomo-style images, featuring light leaks, soft focus and muted colours that give the photo quite a different feel from the original.

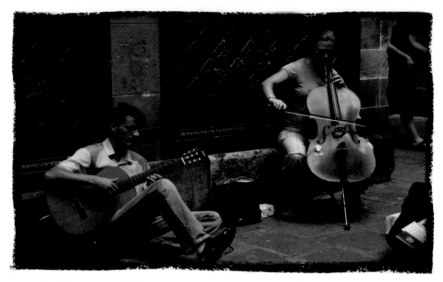

Lomo colour: The Lomo preset in PhotoToaster produces a high-contrast, high-saturation effect similar to that of the film stock recommended for Lomo cameras.

POLAROID CAMERAS

Many would take issue with these being called toy cameras but there's no doubt – as they are now out of production – that they are certainly retro. Like those from Holga and Lomo cameras, photos from Polaroid cameras have a particular distinctive look that's easy to emulate. Here I've used the app 'Instant: The Polaroid Instant Camera' (iOS and Android) to apply effects characteristic of different Polaroid emulsions.

Polaroid photos (opposite): Polaroid-emulating apps create the characteristic look of Polaroid emulsions, including the older, peel-apart emulsions and, for good measure, add in an authentic-looking Polaroid border.

MORE CONTROL

The Toy Camera and Lomo presets that are a feature of so many apps are a great way to quickly apply an effect but if you want more control you can do so by adding each component of the toy camera effect individually. Many apps let you add vignettes, boost the colour, transform the colour and introduce light-leak effects.

EXAGGERATING PERSPECTIVE

Way back in Chapter 1 we looked at depth of field: the part of a scene that is in good focus. We could manipulate the depth of field – making that in-focus zone deeper or shallower by decreasing or increasing the lens aperture respectively.

Some time ago, someone cottoned on to the fact that if you exaggerate the depth of field you can get some fascinating perspective effects, especially when you apply them to scenes – such as landscapes or cityscapes – where normally the depth of field would extend through the whole scene.

Originally photographers would use special lenses that let you tilt and shift the front part of the lens relative to the film or image sensor. Such lenses were expensive, specialized and needed a good deal of practice to master.

Now, with the right apps, we have a wonderful shortcut to creating these exaggerated perspective effects and producing shots where a cityscape looks like part of a world in miniature.

FEATURED APP: TILTSHIFT GENERATOR [IOS] [ANDROID]

APPLYING EXAGGERATED PERSPECTIVE

Giving a scene an exaggerated perspective is simple, but it does require that you start with a subject that's likely to give a convincing effect. Those that work best are landscapes, cityscapes or other scenes where there's already some degree of depth – foreground and background – either side of the main part of the scene.

In the example here there's a row of boats at anchor, lined up side by side heading away from us. This will allow us to make those closest and further away look blurred through faux depth of field effects and make the row look like a collection of models. The application we're using here is TiltShift Generator.

You can create your exaggerated perspective shot in three simple steps:

• Determine the point you want to be the subject (i.e. that in sharp focus) and move the focus point to it.

• Align the horizontal lines with the plane you want to stay in focus and move the inner lines to include all those parts of the image you also want to remain in focus.

• Move the outer lines to define the area you want to be blurred.

You can preview the result straight away and if it doesn't look convincing fine-tune the focus lines.

See page 19 for another example of the TiltShift effect.

Harbour scene: In sharp focus throughout.

TiltShift Generator: In the app you need to define which parts will remain sharp and those you want to be blurred away.

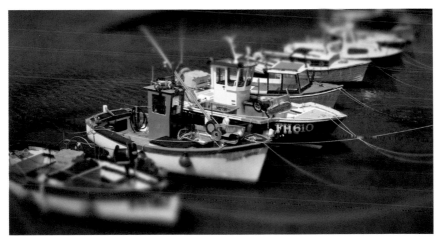

Toy boats: After applying the modifications our full-size scene takes on a miniature appearance.

ADDING SOFT FOCUS
EFFECT FOR DREAM-LIKE IMAGES

You might think producing a soft focus image is easy. It's just a matter of shooting slightly out of focus, isn't it? Not quite. A soft focus photo combines a pin-sharp version of the image with a softer, hazier one. This preserves the details of the original but has some of the finer details – or blemishes in a portrait – are smoothed away.

Traditionally photographers used special soft focus filters or a fine mesh, more often than not a pair of fine women's tights, over the lens to give a degree of softness. The lens on most smartphones is too small to use either method successfully, but there are two easy-to-use alternatives:

• Use an app to apply a selective or general soft focus to a sharp photo.

• Use computer software to create a blurred layer that you then combine with the original sharp image.

The second option provides the most control and flexibility but requires you to download the images onto your computer. The first gives fast – immediate – and surprisingly good results. The images opposite have been created using the appropriately (and obviously) named Soft Focus app.

FEATURED APP: SOFT FOCUS [IOS]. SOFT FOCUS EFFECTS ALSO IN PHOTOSHOP EXPRESS [IOS] [ANDROID]

APPLYING A BLUR

The benefit of using an app (or software) is that we are modifying an existing image. The traditional method of using a filter (or pair of tights) irrevocably applies the filter effect. With an app we can vary the effect as much as we like, altering it from the subtle to the more extreme.

Apps like Soft Focus use sliders to allow you to increase or decrease the amount of soft focus applied and also alter the brightness and colour saturation of the scene.

Doll: Before and after. The softening effect imparts a delicate romantic feel to your shots that are particularly suited to feminine subjects.

Boathouse: A soft focus image is not blurred, you can still see the fine detail in the photo but it still has an overall soft and dreamy look

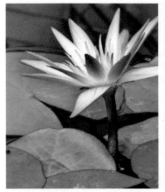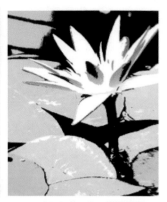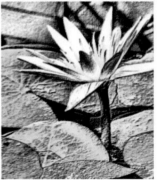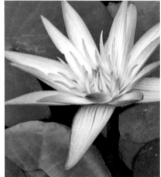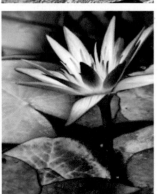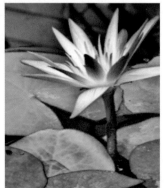

5 HOW TO...

With so many apps available today, the number of distinctly different images that you can produce from a single source image is amazing. It's also amazing how awful many of those will look. You can't just apply an effect from an app and expect to produce a brilliant image. But when you gain an understanding of apps and how they work you can begin to identify what images will benefit from treatment.

Conventional photographic wisdom says that if you must modify an image you should be sparing with the effect and never – or only rarely – apply more than one effect.

Many smartphone app users don't seem so influenced by conventional wisdom and aren't that concerned if images ultimately lose their realistic photographic look. In fact apps make you – almost demand you – go a step further, producing images that are stylized and graphic.

Where smartphone apps really score, though, is in their ease of use. Unlike the conventional image editing applications you'll find on your computer, smartphone apps have to be simple to use: there just isn't the scope to do fine or detailed work on a smartphone screen. And, to be honest, we don't want them to be difficult to use. We want to be able to produce punchy, impactful images simply.

So over the next few pages we'll look at some exemplar images, investigate their conception and then see how easy they were to visualize.

RESIZE
AN IMAGE

When we creatively crop an image we trim it, inevitably rendering the overall image size – and the file size – smaller. Sometimes, though, we need to reduce the image size without paring away any of the scene. We need to reduce the size – in terms of the number of pixels and consequently the resolution.

Why might we want to do this? It might be because we want to email an image or use it on a website, where a smaller image is not only sufficient but also more expedient to send over the internet. Or it may be that we need to provide an image of a certain size for a particular use. Facebook, for example, asks that we provide certain sized images for avatars and banners.

APP NEEDED: BATCHRESIZER [IOS], IMAGE RESIZER [ANDROID]

Available on the App Store

Available on the Android App Store

ADJUSTING THE IMAGE SIZE

• Open the resizing app. There are suggestions above, but there are plenty of alternatives. Some can be used to adjust the size of a single image and some can apply the same change to a batch of images – ideal if you've a collection of images you want to reduce in size for a website.

• Select the new size. You may have the option of some popular presets (using standard dimensions or overall image file size) or you can enter your own.

Done	Resize Settings	Edit +
No Resize (90%)		(i) >
Crop a Square (90%)		(i) >
W:1280 x H:1280 (90%)		(i) >
W:1024 x H:1024 (90%)		(i) >
✔ W:960 x H:960 s (90%)		(i) >
W:800 x H:800 (90%)		(i) >
W:640 x H:640 (90%)		(i) >
W:480 x H:480 (90%)		(i) >

New size: Resizing apps give you the option of a number of preset sizes

• Optionally you can specify a quality for the image: more compressed files are smaller (and easier to email) but will not have the same quality as a larger file.

• Save the new file.

Normally if you resize an image both dimensions will be reduced in proportion, but you can also reduce the sizes of the dimensions independently. You'll get a squeezed look to your image, but it's a useful choice if you need to put a full image in a fixed frame size – such as a Facebook banner.

CREATING A WALLPAPER FOR YOUR SMARTPHONE

You've probably got some great images – so why not show them off as the wallpaper for your smartphone, the image displayed on your lock screen or behind the icons for your apps? Specialized resizing apps can resize your images to make them a perfect fit for screen wallpaper.

Wallpaper: Resize your best images for your smartphone's screen.

TIPS

• Always keep a copy of the original image when producing a smaller copy. You can't enlarge the smaller version and return to the same quality as the original.

• Don't consider enlarging an image to a larger size if you want – say – to produce a larger print. A larger image file is merely that: larger. It doesn't have any more detail than the original-sized image.

A HIGH-KEY, SOFT PORTRAIT

Here's a simple way to create a high-key, soft, romantic portrait. High-key? That's the term photographers use for those bright, light portrait shots where it's the light tones that dominate.

The technique uses both the soft focus effects we've seen earlier and image layers, something you'll be familiar with if you use computer-based image manipulation software. You can upload your images to a computer to take advantage of these (using the upload technique we describe on page 220) or use an app like Stackables that allows you to create multiple image layers.

APPS NEEDED: STACKABLES [IOS] OR PHOTOSHOP ELEMENTS, PAINTSHOP PRO [WINDOWS, MAC]

Before and after: Producing a soft, high-key portrait involves reducing the dark tones and giving the image overall softness – without losing the sharpness of the original image.

Preparing the image: Adjust the brightness and contrast to brighten any shadow areas a touch (don't go overboard, we still need some dark tones in the image).

PREPARING YOUR IMAGE

For a high-key effect you need an image with few dark tones, especially around the subject. You can gently adjust the brightness and contrast to lighten the subject and surroundings. If your subject has lighter skin, you can even use a modest amount of HDR, but avoid this if your subject has dark skin as the lightening effect will be too extreme and unnatural.

PRODUCING A HIGH-KEY EFFECT

Now open your image in Stackables (if you're using the app on your smartphone) or in your image manipulation software on your computer. Create a copy of the image in a separate layer and apply a blur to it. Now locate the layer blend modes and select Screen. You'll get a brighter, lighter image from the combination of the two layers.

SOFTEN THE IMAGE

To give the image a soft focus effect you can use apps like Soft Focus. If you're using software, add another layer, blur it, and reduce the intensity of that layer to about 50%. That allows the sharp image layer below to show though and maintain image sharpness.

A LIGHT FINISH

To finish off the image a white vignette has been applied to lighten the edges of the shot and reduce the dark tones further. Most multi-effect apps feature vignette options – you can alter the degree and size of the vignette to suite the image.

Combining layers: Using layer blend modes produces the high-key effect (shown here in Stackables and Photoshop).

Softening the image. Use a soft image app (page 188) to give the image a soft, dreamy look.

TINY PLANET

Here's a really fun effect that looks a lot more difficult to produce than it actually is. In fact, it also takes longer to describe than it does to create. It's called tiny planets (or small worlds) and creates a whole planet from a modest panorama.

APPS NEEDED:
360 PANORAMA [IOS AND ANDROID] TINY PLANET PHOTOS [IOS] TINY PLANET FX PRO [ANDROID]

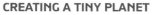

CREATING A TINY PLANET

The source of any tiny planet as just mentioned is a panorama. For best results – and a more detailed tiny planet – this panorama needs to be a full 360 degrees. The built-in panorama feature on a smartphone camera tends to deliver less than 360 degrees so you might have to download an alternative such as 360 Panorama (iOS and Android).

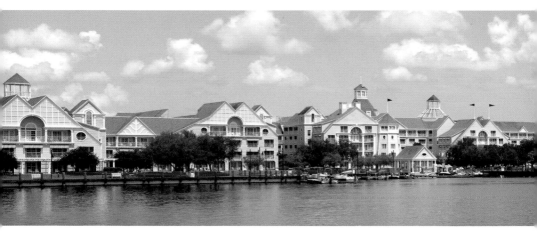

Tiny harbour: As a tiny planet these harbour buildings encircle the bay.

Harbour scene: The original harbour panorama is not a full 360 degrees but all the buildings are a similar distance apart, ideal for creating a tiny planet.

Don't worry, though, if you can't capture a full panorama: you can still create a tiny planet, although it may not be perfectly formed where the two edges meet up.

Tiny planets have been around for a while but required the use of desktop image editing applications like Photoshop. You had to resize your panorama into a square, invert it and then apply a polar coordinate transformation. The results, when successful, were worth the amount of effort involved.

Now you can do the same with a single keystroke with an app such as Tiny Planet Photos for iOS or Tiny Planet FX Pro for Android. Just select an image – your panorama – and apply. Job done. Here are a couple more examples.

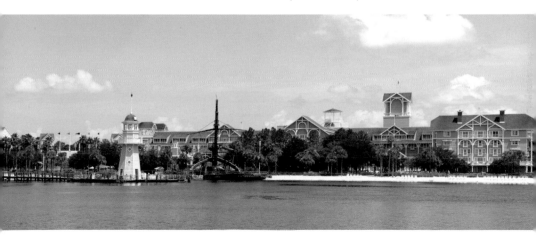

ENHANCING
AN IMAGE

The auto enhance button that you'll find as standard on smartphone camera apps can bring life to an otherwise flat image. At a single stroke it applies a sensible boost to the colour and contrast and corrects any imbalance between the light and dark parts of the image.

It's not always successful, however, such as when the image is, in colour and contrast terms, unusual. This can be the case when your source image has strong colour casts or was taken under unusual lighting conditions. Don't worry, though, you can quickly master image enhancement skills that will improve just about any image.

When the photo here was shot, the building – Humayun's Tomb in India – was lit by the most delicate colours. However, this mix of colour and the camera's automatic white balance has rendered the colour palette rather lacklustre.

APPS NEEDED:
PHOTOGENE, SNAPSEED [IOS AND ANDROID]
OR ANY COMPREHENSIVE PHOTO EDITOR APP

Before and after: With just a few keystrokes the uninspiring colours of the original image are restored to those that actually illuminated the scene.

ADJUSTING THE CONTRAST AND BRIGHTNESS

Using the brightness and contrast controls on your smartphone camera's Photos app, adjust the contrast. You want a full range of tones, from blacks though to white, but with neither predominating. In parallel, adjust the brightness to help you get that full range of tones.

Adding punch: Adjust the brightness and contrast to give a full range of tones. You'll see straight away that your image has added impact compared to the rather flat original.

INCREASE THE SATURATION

Increase the saturation level to make the latent colours in the scene more visible. Resist the temptation to add too much: softer but more obvious pastel colours will be more appropriate here.

Restoring colour: Boosting the saturation will restore colour but be careful not to overdo it or you'll get digital artefacts that will show up as banding in the sky and blocks or flecks of colour elsewhere.

WARMING THE SCENE

The auto white balance controls of the smartphone camera have removed the warm colour cast in the scene. That's not a camera fault – it's just doing its best to get things right. Restore this by adding a warming effect. Anyone who has witnessed a sunset in New Delhi would agree that the stronger effect is closer to the actual scene.

Warming effect: Choose the amount of warming that gives the image the most authentic or pictorial effect – the two are not always the same.

CREATING A
PAINTERLY EFFECT

Creating a painterly effect with apps is easy. You just find an app for the effect you want, apply it, job done. But is the result really that convincing? Often the answer is no. To get an effect that is more realistic needs a little more work.

Here we'll take an image and give it a watercolour look. This involves our stalwart app, Snapseed. I've used this rather than a dedicated app for art effects as it allows more control over the final result.

APP NEEDED: SNAPSEED [IOS AND ANDROID]

We'll start with this original image. It's a relatively simple scene and one that, conceivably, a watercolour artist might use (in fact when I shot this there were indeed two artists nearby, capturing the view).

STEP 1: GETTING THE BASIC IMAGE RIGHT

Technically the original image is okay but the contrast and brightness could do with a little tweaking. We could adjust these manually but this is one of those cases where the shortcut, auto enhance, works.

Fishermen's houses (top): An ideal scene for capturing as a watercolour.

Auto enhance (bottom): The image contrast and brightness levels are subtly improved.

STEP 2: GO FOR INTENSE COLOUR

Boost the colour saturation by between 40 and 60% until the colours become garish. As well as increasing the saturation of the colours, it also reduces the tonality in each of these colours, giving us free reign to apply a watercolour texture.

STEP 3: APPLYING THE PAINTERLY EFFECT

The watercolour texture we apply to our somewhat gaudy scene is provided by the grunge effect. This has the result of subduing colours somewhat (therefore compensating for the saturation increase) and provides a convincing painterly texture.

The grunge effect, though, is not designed specifically for producing painterly effects, so some fine-tuning is needed. You will need to move though the different filter variations and also alter the strength of the effect to get the best result.

Saturation (top): The massive boost to colour saturation will give us more scope to accommodate effects in the next stage.

The watercolour scene (middle): The applied texture needs to be manipulated to give the most convincing effect and there are no right or wrong settings.

The finished artwork (bottom): When you arrive at settings that seem to work it's time to save your image.

A WARHOL-ESQUE COLLAGE

One of the exciting things about messing around (and meaning that in its most positive sense) with images and apps is that you sometimes find images that produce great new images time and again as you apply different effects. And perhaps proving the old adage that you can't have too much of a good thing, put them together and you can create a graphic collage. A collage that gives a nod to Andy Warhol's pop art posters, perhaps?

APP NEEDED: PIZAP [IOS AND ANDROID]
ALSO TRY: PHOTOWONDER [IOS AND ANDROID]

SELECTING AN IMAGE

Collages are, by definition, collections of multiple images. There's a risk, then, that if you start with a detailed, complex image the collage will appear very cluttered, even if the principal image element is repeated. So go for a simple image, something with a very obvious and bold subject. Think of Andy Warhol's classic pop art image of a posterized Marilyn Monroe. Simple and effective.

For this example we'll use this image of a small section of the roof of the Serpentine Gallery in London.

CREATING THE IMAGE COMPONENTS

Once you've settled on your image, start applying different effects. Use your favourite apps or experiment with some new ones. There's no right and wrong here, it's more a matter of creating versions of the original image that are distinctive and contrasting or which work harmoniously together. How many do you need to create? If you want a bold square, just like that Warhol image, just four – but nine or sixteen (giving 3 x 3 and 4 x 4 square collages respectively) work well too.

CREATING THE COLLAGE

Open the app. Here I've used piZap, which has a very simple interface and makes it easy to choose the component images. You can experiment by changing the position of each of the images to see what works best. Then, when you're done, save the image.

Source image: Here's the image that will form the basis of the collage.

Assembly: Apps such as piZap allow you to place any image in any location on the template.

GIVE THE PHOTO
ALBUM A MAKEOVER

It's great being able to share your photos on social media and by sending email attachments but all these methods do is emphasize the transient nature of digital images.

It's not so long ago that our treasured photos were carefully and dutifully mounted in grand and rather formal albums. Many are still passed down the generations as family heirlooms, of little intrinsic value but beyond price as memories of long-departed family members and friends.

Far from being a historical oddity, the photo album is as popular as ever, even if they have undergone a modest transformation into the photobook. Same concept but with your best photos printed and bound as a conventional book. They're a great way to commemorate a special event or holiday; and it's remarkably easy to put one together – straight from your phone.

PUTTING YOUR BOOK TOGETHER

Assuming you've got all your images already on your phone, you're all set to go. Download a photobook creation app such as PhotoBook (iOS and Android).

1. Choose a theme: there's a selection of book types available – babies, weddings, travel and so on. This will give your photobook the right look.

2. Give the book a title.

3. Select the images you want in your book.

4. Let the app fill the book with your chosen images.

5. If you don't like the automatically generated order of the images you can rearrange them yourself.

6. Finally review the book options and choose the one you'd like produced – small, larger, hardback or softback. And, of course pay.

AVOIDING
AN EPIC FAIL

Getting creative with your photos isn't all about applying apps and effects one after another until the image looks good; it's about knowing what to use and how it can improve an already-good photo. It's also about when to stop.

Let's look at some of the more common editing mistakes. As you'll see, the term 'too much' appears with disarming regularity.

TOO MUCH HDR

HDR is a great way to improve shots, particularly those that would otherwise be too contrasty. But too much HDR and images take on an unnatural tone and colouration. When you apply an HDR effect, use the Amount slider to reduce the amount from the high preset level to that which gives a more realistic effect.

Epic fail 1 – HDR: Too much HDR and your images look peculiar; a dead giveaway that you've applied filter effects.

Epic fail 2 – unconvincing blurring: The photographer here had the best of intentions, wanting to focus attention on the bee. But the blurring around the edges is too overt and contrived.

SPOT FOCUS

Spot focus (or centre focus as it's also called) keeps the centre of a scene sharp and blurs the surroundings. It's something we've used subtly already. 'Subtly', though, is the key. You want to mimic an increased depth of field. Often it's used too intensively and again the results are unnatural.

TOO MUCH SHARPENING

There may be many reasons why an image is not critically sharp. A fingerprint on the lens, a subject that's moved slightly since the camera focused or good old camera shake. Whatever the cause, slight unsharpness can be attended to using a sharpening app or effect.

But sharpening effects can't rescue an image that is hopelessly blurred, nor does applying a stronger effect give a sharper photo. You just end up with a degraded image.

TOO MANY EFFECTS

Start by applying an HDR effect. Not too much, say 50%. Now enhance the detail using a drama filter. As it's now lacking some colour, boost the saturation. Now use a grunge effect to give the scene a gritty look. And apply 75% sharpening to bring out the detail. Sound familiar? We've all done it, and the result is an over processed image. If your image needs that much manipulation, it's probably not that good in the first place. Less is definitely more.

Epic fail 4 – just too much: Sometimes applying multiple effects works. But often the effect is something so obviously over-processed it doesn't 'work' as either a standard image or a creatively manipulated one.

OVER-CROPPING

Cropping should mean trimming a modest amount of the image to improve composition. Cut away too much – even with a high-resolution image – and you're left with an image that, with a smaller pixel count and enlargement of a lens's shortcomings, is never going to look good. Especially if you plan to enlarge or print it.

OVER-CORRECTION

Adjusting the contrast and brightness can work wonders with dark or shaded parts of an image. Trouble is, when you get some parts of the image perfect, you can end up overdoing other parts. Some images need selective adjustments using more subtle tools such as dodge and burn (see page 214).

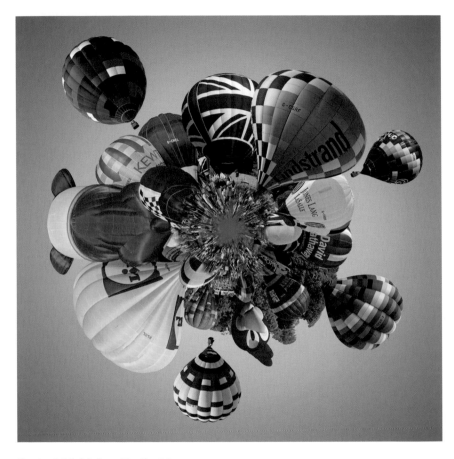

Tiny planet: Hot-air balloons (Tiny Planets)

Mild watercolour: Bouquet of flowers (multiple apps)

GETTING SERIOUS

A presumption many people make – especially seasoned photographers, who really should know better is that smartphone cameras aren't up to some of the more meaty and advanced imaging tasks that pro or enthusiast kit can do.

They will argue that smartphone cameras are more lightweight (in features and actual weight) so may be ideal for carrying where you might not want or be able to take more heavyweight kit, but when it comes to the crunch, they just can't do everything that might be demanded on a photographic assignment.

Of course, there's truth in that. But it's fair to challenge it too on the basis that there are things a smartphone can do that your typical digital SLR can't – or certainly can't so easily. So in this chapter we'll take a look at some advanced techniques where a smartphone camera really can excel.

We'll also look at some ways of bridging the gap between the conventional photographic world and that of the smartphone. Addressing any shortcomings of the smartphone camera and also seeing how some of the power of the smartphone can be employed to give users of normal digital cameras more creative opportunities. Truly getting, even if it is something of a cliché to say it, the best of both worlds.

DODGE
AND BURN

The majority of photo apps are based on simplicity: a single keystroke or touch of the finger that transforms your image. But there will be times when you want more subtlety. Such as applying transformations to selective areas of images.

DISCOVERING DARKROOM TECHNIQUES

When they wanted to produce a winning print, photographers used to retire to the darkroom and apply some cunning techniques. Rather than expose the paper evenly, they would shade parts of the paper for part of the exposure and give others an extra bit of light.

These techniques are known as dodging and burning respectively and their effect on the photographic paper image is to render those parts of the image lighter or darker than they would otherwise be. In the absence of digital techniques it was the only way to, for example, emphasize contrast, or put detail into a sky that would otherwise be bland. Getting it right takes a lot of experience and a fair amount of luck. And it's hard to get the same result twice.

Once digital image manipulation software appeared, it made dodging and burning easier. You could use a dodging brush to lighten selective areas and a similar burning brush to darken others. You still needed a bit of skill to know how best to apply the emphases but you could see – and refine – the results immediately.

You can do the same with your smartphone images, using apps like Photogene (iOS and Android), where you can find the dodge and burn tools by selecting 'Retouch'.

DODGING AND BURNING

Subtlety is the key to using these tools. Use the dodge tools to gently lighten the brighter parts of the scene and the burn tool to darken the more shaded as you gently enhance contrast. You can also use the burn tool to add more detail and texture to otherwise featureless areas (such as, as already mentioned, overcast skies).

Don't be too heavy-handed when using these tools. Stand back to examine your work every

so often and, if you can, compare the image with the original.

To be honest, the screen of a smartphone is a touch too small to adjust the finest of details and you'll have greater success if using a tablet. Either way, though, if you want to enhance your photos in a way that is more delicate than the rather brutal approach of some apps, it's worth getting to know these new versions of traditional tools.

Darkroom tools: Photogene is one of the few apps that offer tools familiar to those used to working with computer-based image manipulation.

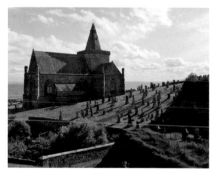
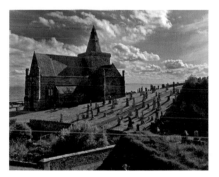

Scottish kirk: With strong backlighting, the smartphone struggled to get a perfect shot of this church. Applying an HDR-style effect to even out the brightness was unsuccessful: the result looked too unnatural when a high level of effect was applied and ineffective at lower levels.

The burn tool was used to darken the over-bright sky, providing more texture in the clouds. The dodge tool was used on the church itself, to lighten the dark shadow areas. Areas such as the grassy knoll were left alone to preserve the luminous look.

For a final flourish the image saturation was increased a small amount (less than 10%). This was to restore the colour in the scene that was a touch suppressed due to the backlighting.

PANORAMIC
PHOTOGRAPHY

As we saw earlier (on page 90), panoramas are a great way to get those really jaw-dropping ultra-wide shots. Shooting panoramas is increasingly popular and one of the reasons that most smartphone cameras will now let you shoot a panorama by simply scanning the view.

These features, though, can be a bit limited. They are also rather constrained, providing only a limited width of panorama. And they don't allow you to pan the camera up and down to shoot vertical panoramas.

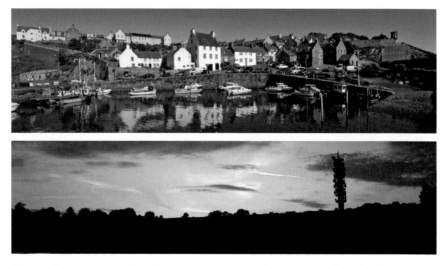

The wider view: Panoramas can be a full 360 degrees or less, according to the subject. Here six images were stitched together to give a modest panorama of around 120 degrees.

Dramatic sunset: Once you've produced a panorama, you can treat it like any other image: it can be cropped and edited, and effects can be applied.

Never mind, there are plenty of panorama apps designed to overcome any shortcomings of the inbuilt app.

CREATING A PANORAMA

Many of the apps you'll come across use the step-by-step approach to building a panorama. You start at the left-hand side of your view and take a photo. You then move the camera to the right and take another. And another and another, until you've included everything you want. That could be three or four shots or, for a full 360 degrees, a dozen or more.

What's important is that each shot overlaps the previous by around 25%. This will allow the panoramic software to blend together successive images. You also need to ensure that you keep the camera level throughout to avoid distortion. Don't worry about being too precise though: if you are using an app, such as 360 Panorama (iOS and Android), you'll be helped though this technical stuff as the app will indicate if the shots are level and the amount of overlap.

UP-AND-OVER PANORAMAS

We conventionally think of panoramas as horizontal but they can also be vertical, with images taken one above the other. Take that to the extreme and you can shoot a full 180-degree panorama from one horizon through the view overhead and down to the horizon opposite.

AUTO PANORAMA

The nifty app Cycloramic (iOS and Android) uses a novel approach to panorama generation: using the camera's inbuilt vibration system, it gently pans the camera automatically to generate the panorama. It guarantees the panorama is level and the image data is gathered at a constant rate.

Cycloramic: Get your panorama automatically using a compatible smartphone and the Cycloramic app.

INTO THE
THIRD DIMENSION

Photography's flirtations with 3D images have been numerous. Almost from the first days of photography, pioneers sought to produce images that could replicate the depth in the original scene. Many a Victorian family had a table-top stereoscope and collection of world view stereographs – 3D photos.

The more compact View-master provided an update to the stereoscope concept in the middle of the twentieth century, giving 3D photography a minor fillip as did a burst of movies shot in 3D. Movies in 3D would see another renaissance in the 1970s and again – perhaps with a greater degree of acceptance – in the 2000s. Then it was a combination of movies that exploited the third dimension and technologies that made them more convincing to view which proved a winning combination.

3D ON YOUR SMARTPHONE

It's perhaps not surprising, then, that developers saw the smartphone camera as a new frontier in 3D photography and took the opportunity to design new apps. They had to be ingenious: in practical terms smartphones are not designed for 3D, having only a single lens rather than the two needed to record in 3D. So novel solutions have been adopted.

Apps like 3D Camera Lite (iOS) and 3D Camera (Android) take a traditional approach to 3D photography, one that many photographers have used over the years. It requires two separate photos. First, you shoot a photo of your scene. This will be your left-eye view in the finished stereograph. Then you're prompted to take a second photo, from a position slightly to the right. You'll see a faint image of your first shot so you can get the alignment right.

Once you've both photos in the camera, you can view them. Viewing options include side by side (where both images are presented side-by-side, and you view the left with the left eye and right with the right eye), cross-eyed, coloured glasses and wiggle. In the latter case, both images are presented in rapid succession to give the impression of depth without the need to cross your eyes or use glasses.

The results can be quite effective, and even more so if you download the stereograms to your computer where you can view them on a larger screen. The drawback is that, as both photos need to be shot consecutively rather than simultaneously, it's no good for moving subjects. Anything that has moved between exposures appears as a ghostly image in one or both shots.

AN ALTERNATIVE APPROACH

One of the drawbacks with 3D technologies over the years and something that has probably restricted its widespread acceptance is the difficulty in viewing. You can't just look at a 3D image and see it in all its depth. You need to use a viewer or train your eyes to see the depth in parallel images (okay, so I'm ignoring here those lenticular images you could view as 3D prints, but they had their own problems...). Like most technologies, widespread and long-term acceptance is never assured unless they are fiendishly easy to use.

That was the argument of the team behind the app Seene (iOS). They wanted to create 3D images that didn't need special glasses or eye techniques to look at images in contrived ways.

With Seene you photograph an object from different directions. These are amalgamated into a single image that you can look around by merely tilting your smartphone to the left and right and up and down.

Look around: Seene may not offer true 3D images (i.e. images with perceived depth) but the results can be very effective, allowing you to easily explore a subject from different directions. Following the onscreen green arrows, you photograph the subject from above, below, right and left, building up an omnidirectional image, viewed by moving the smartphone around. Sadly the effect can't be shown here as it does not translate to the printed page!

USING YOUR COMPUTER TO MANIPULATE SMARTPHONE PHOTOS

The apps on your smartphone are great for quickly enhancing your photos – for example correcting exposure problems, converting to black and white and creating art effects. What all these apps have in common is that they apply corrections or enhancements across the image. Yes, there are some apps that can apply localized corrections, but what if you want to do something more radical with your images? Take out an element or apply a subtle effect to a very small area, too small to manipulate with a finger? It's time to resort to a computer-based application.

TRANSFERRING SMARTPHONE PHOTOS TO YOUR COMPUTER

Obviously, to manipulate your images on a computer you first need to transfer those images to your computer. How? It'll depend on your phone and computer.

Image manipulation: If you want to perform delicate image manipulations or localized modifications beyond what smartphone apps offer, upload your images. Working on a computer monitor also gives you more space to work with, compared to a smartphone screen.

Direct transfers: With cloud-based systems like iCloud, images can be instantly transferred between your phone and computer. Similarly, your computer-edited images can be returned to your phone so you can carry the enhanced versions around with you.

If you've an iPhone and a Mac and have an active iCloud account, you'll find images automatically transfer. Even when you are out and about and your computer is running, photos you shoot will, shortly after, appear in iPhoto. They'll also appear on an iPad if you have one and any other registered devices.

If you've an iPhone (or a different smartphone) and Windows PC, then the process is almost as simple: you'll have to connect the phone to the computer and follow the upload instructions.

You can also use cloud-based file sharing apps like Dropbox to share image files between devices. Or, for a more ad hoc approach, send individual images via email (though be mindful that this may incur a cost if you don't have an unlimited data plan).

MANIPULATING UPLOADED IMAGES

Whatever means you use for uploading, once on your computer they can be treated just like any other images – such as those uploaded from a conventional digital camera.

Open them in any image manipulation software. Pro photographers stake their reputation on Adobe's Photoshop, an application that can do just about anything, but it comes at a price, often beyond most photographers. Fortunately there are cheaper alternatives. Adobe offers a trimmed-down version of Photoshop – Photoshop Elements – that offers just about

all the photographic enhancement tools you need. Corel's Paintshop Pro is another keenly priced alternative. But look around the web and you can find free photo editors. They may not have all the bells and whistles, but what they don't offer probably doesn't really matter that much.

BACK UP YOUR IMAGES

Uploading your smartphone images to your computer is recommended in any case – even if you don't plan to edit them. It means you have a back-up copy on your computer – so if anything happens to your phone, your photos are not lost.

Go a step further, though, and make a second copy of your photos – to CD, DVD or an external hard drive – so your image collection is as safe and secure against potential hardware problems as possible.

You can use specialist software to back up your images but it's just as easy to simply make a copy of the folder containing them to disc.

EDITING CAMERA PHOTOS ON YOUR SMARTPHONE

The process of transferring images between smartphone and computer is very much two-way. So, just as you can send images from your smartphone to your computer to perform advanced edits, so you can transfer other images – taken with your digital camera for example – from computer to smartphone.

Why? Well, you can take advantage of the apps on your smartphone. Computer image manipulation applications can do just about anything to your images – but doing so can involve a degree of expertise and methods are rarely the most expedient. Plus there are all the fun and creative apps that you gain access to.

SENDING IMAGES TO A SMARTPHONE

Ostensibly, the process of sending images to a smartphone is the reverse of uploading smartphone images to a computer. If your devices are synchronized via a cloud service, you should find image transfer is automatic. Images you've edited and stored in iPhoto, for example, will be available shortly afterwards on your other devices, including your iPhone.

Downloaded images: Once images are downloaded from your computer to your smartphone they are added to your photo library and can be treated in just the same way as any photos shot using the smartphone camera.

There's also the standby of emailing selected images, to be picked up on your phone.

USING SMARTPHONE APPS ON DOWNLOADED IMAGES

Once on your phone, your downloaded images will be added to your photo collection and can be manipulated using any of your photo apps. Everything will work in exactly the same way as if the images had been shot on your smartphone camera.

Once you've performed your edits, you can save your images – locally or back to your computer (as described previously) – or both. What you will often find is that your images are now smaller – with a lower resolution – as most phones tend to reduce the size of images processed upon them to that of the smartphone's own images.

This is obviously a concern if you plan to print your images to poster size but often the trade-off in quality compared with great effects you can apply is worth the compromise. And at the size most images are viewed, the reduced resolution will be of little consequence.

False infra-red effect: Some apps on smartphones don't have an equivalent in the computer image enhancement world or would be laborious to recreate. Hence dropping them down to your mobile phone is a remarkably effective way to produce some powerful images, such as this false infra-red effect.

Adding Drama: We've looked at the Drama effect in Snapseed a number of times. There's no obvious computer-based equivalent, so to apply it to a photo taken with a conventional camera, send your photo to your smartphone instead.

DO MORE THAN SHOOT PHOTOS AND VIDEO CLIPS

Smartphones make it easy to shoot video clips. Fiendishly easy, in fact. But if you want to shoot something a bit more ambitious – a mini movie blockbuster, no less – is it really that difficult? Well, like shooting a great photo rather than one that's merely okay, it takes a bit of practice, but follow a few simple rules and you'll be well on your way.

• Preparation: before shooting your first blockbuster take a look at some movies that have been shot on smartphones. All the top video sharing sites feature such footage (funny how we still talk about footage, as if we're still shooting film) and are ideal for studying how the professionals and enthusiasts go about shooting a movie.

• And more preparation: get the measure of your smartphone's video mode. You may be totally au fait with the camera and all its features but in video mode there may be some limitations.

• Tell a story: if you want to make a movie rather than just produce a random selection of video clips, put together a storyline. Think of the shots you want to shoot and in what order. Think too about the way you want to set up each shot so they'll look at their best. Then note down all you want to shoot so when you're done you'll know you've captured all the material you need.

• Stick with landscape mode: there will be occasions when you shoot very effective movies with the camera held in vertical/portrait mode but for a movie, stick with the more conventional landscape mode for all shots.

• Dry runs: to get the best results, do a dry run of each shot to ensure the lighting and composition are as good as they can be. You'll be able to determine whether any changes in lighting, for example, are adequately accommodated by the camera or if you need to compensate with a further change in the lighting.

• Let your subjects do the moving: unless you're following some fast-moving action sports, keep the camera steady – even on a support if you can – and let the subjects move around. Camera movement can be uncomfortable to watch – and too much movement can make your audience nauseous! Similarly avoid zooming during a shot (if your smartphone permits it) and avoid the zoom

altogether if you can. Zooming in fully can lead to a lower-quality image and exacerbate any camera shake, more obviously than might be the case when shooting still images.

• Remember you can still shoot still images in between shooting movie clips. And that video editing and compiling apps can let you add images to the video too.

• Edit your movie: no movie is perfect straight from the camera, and in any case you'll have to assemble your individual clips into a continuous movie. You can do so by transferring to a laptop or desktop computer, but it's much more fun to do it using a movie editing app.

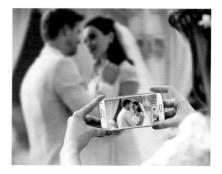

Shooting video: Don't move your camera unnecessarily, either deliberately or through camera shake. It's always best to let your subjects provide all the action. And if you have to hand-hold, make sure you've a steady grip. (Courtesy Samsung)

MOVIE EDITING APPS

You'll find movie editing apps suitable for all levels of movie making available for iOS and Android, many of which offer the frame-by-frame control you might find on a computer-based movie editor. But if you want to create – and share – a fun movie, take a look at apps like Magisto (iOS and Android). This presumes you know nothing about video editing and automatically stitches together your video clips – letting you add images, graphics and music too.

For something a bit more beefy that gives you a little more control but is still easy to use, take a look at Splice and Cinefy (both iOS and Android).

Magisto: Pick your clips, choose a theme, select some music and produce a movie on your smartphone in minutes with Magisto.

7 TOOLS AND ACCESSORIES

If you are an established photographer, coming from a background of conventional digital cameras or even film cameras, chances are you won't just own a camera and possibly an additional lens or two. You'll have a kit bag full of what might euphemistically be called accessories or 'stuff'. And back home there will be a draw or cupboard filled with more.

Some of this stuff may be useful: a tripod, rugged case, extra camera body. Then there's all those reflectors and flashguns used for some high-quality portraits. And, for good measure, some filters. Not necessarily kit that gets used everyday, but stuff you might consider for a particular adventure.

Then there is a lot more – and I mean a lot – that is harder to justify, yet you are loath to get rid of it. Accessories that seemed a really good idea when you were at the photo store but, when you actually came to use them, didn't really bring anything to your photography. Or those you bought for a long-gone camera.

It should come as no surprise that the market for accessories is buoyant – and often brings retailers more income than camera sales. And it should equally come as no surprise to find that this market has now grown to provide useful tools for smartphone cameras. So, before you are tempted to part with hard-earned cash, let's take a critical look at some of the more useful accessories that can take your smartphone photography further.

ACCESSORY LENSES

We've seen how the lens of a smartphone camera is pretty good and able to deliver quality images. That's not to say your typical smartphone lens doesn't have its shortcomings. The zoom, for example, is not always that impressive. At its widest setting it's not really wide enough to capture shots in confined spaces. When zoomed, by virtue of the digital zoom, resolution and quality can tail off. And that zoom is often a little too modest to let you get in close on distant details.

Faced with these shortcomings, you won't be surprised to hear that there are plenty of accessory lenses out there to embellish your smartphone; perfect for extending your photo opportunities. Let's take a look.

TELEPHOTO ACCESSORY LENSES

There's no doubt that getting close to a subject gives more impact. Sometimes we can do that by physically getting up close, or using the camera's built-in zoom. But when neither option is sufficient, that's when an accessory telephoto lens comes into its own.

Compressing perspective: As well as letting you really fill your smartphone camera's frame with your subject, a good telephoto lens will also let you compress perspective, as with this street scene. A grain effect app and a touch of colour saturation have been added for a gritty yet colourful image.

These offer up to 10x image magnification (producing a magnification equivalent to around 400mm compared to full-frame digital camera lenses) and make best use of the smartphone camera's image sensor for a quality, detailed image.

Widely available (particularly online), it's best to go for one matched to your smartphone model – which will give the optimum image quality. There are magnetic and clamp-on models available too, making them easy to slip on when needed.

Details: For most people the *raison d'etre* of a telephoto lens is to get in close on details, letting you crop away any distracting – or bland – surroundings before taking the shot.

WATCH OUT FOR...

Using accessory lenses is fun and can deliver great photos but you do need to be mindful of a couple of limitations:

• Exposure increase. Your accessory lens, be it wide-angle or telephoto, puts a lot more glass in front of the smartphone camera's own lens and so can cut down on the light getting in. Exposures will be longer so make sure you keep the camera steady when shooting.

• Camera shake. With a magnification twice that – or more – of the standard zoom lens, the risk of camera shake is similarly magnified. Again, make sure your camera is held steady (or better still, supported) when shooting.

• Plastic lenses. Some adaptors have plastic lenses that are not always of the best quality. Glass-lensed adaptors may cost more but will, ultimately, deliver better quality.

Sea front: Shooting with a really wide-angle perspective gives this coastal scene much more impact than it would have with the smartphone camera's lens alone. A pastel painting effect has been added to perk up the image a little too.

WIDE-ANGLE ACCESSORY LENSES

If there is one thing about the lenses on smartphone cameras – and those on compact cameras for that matter – that irritates users, it's their inability to go really wide. Of course, there are ways around it, such as panoramic techniques, but these aren't always suitable or convenient.

Cue the wide-angle accessory lens. This attaches to the smartphone camera's lens in just the same way as the telephoto lens and gives you the ability to capture a much wider view than the camera's lens alone could.

For best results when using one of these, keep the camera level, especially when shooting indoors – this will avoid, or limit, the chance of shooting a distorted image. And get some foreground interest in shots to avoid having too much empty space in wide-angle landscapes.

GETTING IN CLOSE

If you've a penchant for the really small – whether it's collecting coins, miniature figures or exploring the tiny details on everyday objects, then you need to go for a close-up or macro adaptor. You can focus up close with your smartphone camera's own lens but the macro adaptor lets you get really close: just millimetres from the front of the lens.

Take care when shooting. Focusing is critical when shooting the macroscopic world, so if you can mount your camera on, say, a table tripod, you'll get much better, sharper results. Take care too that your smartphone doesn't shade your scene – easy to do when you are so close to your subject.

Macro lenses: Macro lens adaptors let you get in really close to a subject. Using a mini tripod is advised to keep subjects like this square on to the camera and in focus.

Up close: Capture the details in an eye using a macro lens. The smartphone camera's flash was used here, but attenuated (by using a bit of cloth) so it did not cause the subject any problems.

GOING REALLY WIDE

Look out for fisheye adaptors for the really wide view – taking in a full 180 degrees.

LOOK OUT FOR LENS SETS

Though you can pick up accessory lenses individually, you can often find sets – comprising a telephoto (or two), wide-angle and macro lenses, all at an attractive price.

LENS CAMERAS

Accessory lens adaptors, whether wide, telephoto or close-up, can really extend the scope of your photo opportunities but they are limited. They still rely on the smartphone camera's own lens and sensor and they introduce more glass into the optical path, which can, ever so slightly, degrade the image.

Sony took quite a different path when they launched their QX lenses for smartphones. Rather than augment the existing camera, these lenses are, essentially, complete cameras in their own right, and cameras that don't need to interface with the built-in camera in any way.

Within what looks like a conventional camera lens is not only the optical elements for (depending on the model) a 10x zoom lens but also an image sensor. One of the launch models also included a pretty meaty sensor, a full one inch and with a resolution of over 20 megapixels. It's the same sensor that's been used in the well-regarded Sony RX 100 camera, a very serious conventional camera.

These lens cameras also offer wide maximum apertures that, coupled with the geometry of the lens, allow for more pronounced depth of field effects than the standard smartphone camera can offer, along with commendable

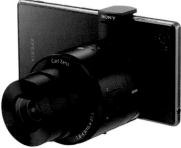

QX100 lens camera: Here mounted on a smartphone, it can also be used separately for more experimental photography.

low-light performance. What you might expect from a middle-market digital camera.

This lens camera communicates with the smartphone using Wi-Fi, and a camera app (iOS and Android) gives full control of the camera features. Though you can mount the lens camera on your smartphone, you needn't do so: you can place the lens camera in an unusual or difficult-to-get-at position and monitor the output on the smartphone's screen.

Roman baths: This shot of the Roman baths in Bath, UK, shows the potential of a lens camera, able to produce a very detailed image with good dynamic range. A modest amount of HDR effect was applied to the image to improve the look of the sky.

SUPPORTS, CASES AND MORE

Here's a few more accessories that can really help give your smartphone photography a boost.

SUPPORTS

Some conventional photographers don't go anywhere without a tripod. Every shot they take will be rock steady. That can be a bit of overkill, especially for situations where the light levels are high and, consequently, exposure times are brief, making the possibility of camera shake negligible.

Supports: Even the most modest of supports will help you get better – sharper – images when exposure times start increasing beyond what is safe to hand-hold. A flexible support such as this GorillaPod provides many support opportunities. (Courtesy Joby)

Sunset: Though the sky is bright, the exposure time for this shot would preclude a hand-held shot. Using a GorillaPod wrapped around a fence post enabled the colour in this post-sunset shot to be accurately recorded.

As we've seen, though, when the light levels fall, exposure times can become long. That will lead to blurred images. And it's a similar story if you opt to shoot at full zoom or add in a telephoto lens converter, either of which will amplify any camera shake.

Lets face it. Many of us use a smartphone for its practicality – you can carry it everywhere easily. It's neither practical nor convenient to carry a tripod around with you, but when you want to shoot some photos and exposure times are going to be a problem, slip a pocket tripod in a pocket or bag. The ever-popular GorillaPods offer a small smartphone model that's robust enough to keep your smartphone steady, particularly when wrapped around a convenient post or railing.

CASES

It always surprises me that smartphones don't come with wrist straps as standard. Of course, someone will point out that this would be impractical for whatever reasons. I'm just a little concerned that the way we normally hold a smartphone camera to shoot can be a little precarious.

Never mind, if you're a bit concerned about dropping your phone then it could be an idea to use a ruggedized case. They add a little to the bulk of the smartphone but if the worst happens, you'll be pleased you made this investment.

Rugged cases: They won't guarantee your camera will survive a fall, but the chances of avoiding a smashed screen – or worse – are a great deal better. This model (Survivor, from Griffin) is exceptionally rugged – and protects the camera lens behind a dust proof flap. (Courtesy Griffin Technology)

BATTERIES AND POWER

Surprisingly, the camera options on your smartphone don't put too onerous a load on your battery but, along with all the other things you might use your smartphone for while out on your photo mission – surfing the web, sending emails and checking the weather, perhaps – you might find yourself short on power as the day draws on.

So if you find this happening to you, it's worth investigating auxiliary battery packs. You don't necessarily need to attach them permanently but keeping one – fully charged – close at hand will mean you've enough power to keep going long into the night too.

Extra light: LED-powered compact lighting is a step up from smartphone camera flash and gives a clean white light. Good for video shots too. (Courtesy Photojojo.com)

Remote action: Coupled with an app that provides the functionality, remote releases are perfect for shooting when your camera is out of reach – such as when shooting timid wildlife.

And just to make your smartphone photography complete here are some more accessories. Some may not be essential – indeed some are frivolous. But then, isn't that what smartphone photography is all about?

POCKET SPOTLIGHT

I've mentioned – and you've probably discovered – how the flash on your smartphone is just adequate. If you really need some light and have no alternative then it's something you have to resort to.

The Pocket Spotlight, however, is that alternative. It's compact, weighing much the same as your smartphone, yet it can provide up to an hour's illumination. It's not a flash in the conventional sense – it can provide continuous light – so it's also a useful way of adding extra light to video footage too. It needn't be camera-mounted either – so you can use it for directional lighting for those moody portraits or still-life creations.

REMOTE RELEASE

If you really want to avoid vibrations when using your smartphone camera on a tripod or support, are a devotee of the selfie or you want to fire the shutter remotely, then arm yourself with a remote release. You can fire off one – or many – shots. Models like the Belkin shown here give you the option of shooting video remotely too.

HOLGA FILTER SET

Okay, we've visited the subject of toy and retro cameras – such as the Holga or Lomo – already (page 182), but that was all about recreating the unique look of images from these cameras digitally,

using apps. The Holga filter set lets you shoot images with some of those characteristics directly.

The filter set comes complete with a camera-back case that ensures the filter set is always correctly positioned so you can choose from one of the ten supplied filters. As for those filters, they tend to be rather good – there's an excellent macro, coloured filters, multiple image filters and highlight shapes. In fact, rather better than you'd expect to get from an actual Holga camera. Versions are available for all popular smartphones.

Holga filters: The compact and easily selectable Holga filters are ideal for experimenting with in-camera special effects and macro photography.

AND JUST FOR FUN… A 3D ADAPTOR

Shoot traditional 3D images – and view the results – from your smartphone camera with this anything-but-compact adaptor. Slip your camera into the slot and the optical system will let you shoot the two side-by-side images. Then replay those images using the same viewer to see them in their full three-dimensional glory.

Okay, you're not going to carry such a bulky device with you everywhere, but for some fun photos or some more serious explorations into stereoscopic photography, the modest investment will repay you handsomely in fun images.

3D Adaptor: The Poppy 3D adaptor gives your compact smartphone all the bulk of an old instant camera but delivers intriguing stereoscopic images. (Courtesy Photojojo. com)

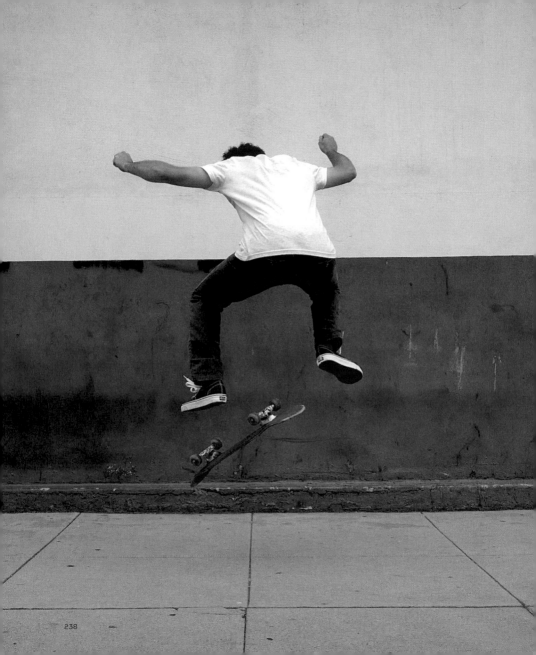

DON'T KEEP
THEM TO YOURSELF

It's not so long ago that photography was, for the most part, a leisurely pursuit. You took time shooting a photo, getting everything just right. You then took some more photos and, if you reached the end of the film, sent it off to be processed. Then, perhaps a week later, you'd review your efforts. And you might show the best of them to your family or friends.

Wow, have things changed. First digital cameras arrived, gently pushing the film camera to the sidelines. Images could be reviewed and shared immediately – even if it was locally on the camera's modest screen.

Meanwhile, elsewhere another technology bubble brought us the digital mobile phone. Pundits started talking about a future convergence of electronic devices, where single devices would gradually assume greater and greater common functionality.

It was in the mobile phone – helped by the Internet – that the dream of convergence became a reality. For us, as photographers, it means that our camera is no longer just a camera and it can share the photos we take (or manipulate) with friends, family or the world instantly.

Now we are spoilt for choice. Do you want to keep your best photos online, where they can be shared with your peers? Tweet your latest photo adventure – or discovery – to an eager audience? Or go a step further and create a website where you can display your best work and sell copies too? It can seem there is no limit to photo opportunities online so let's look at getting started with some of the more popular.

MAKING MONEY FROM YOUR SMARTPHONE CAMERA

It's great to share your smartphone photos, whether it's to show off your photographic prowess or just to share your family news in pictures. But wouldn't it be even greater to make money from your smartphone images too? You may be surprised to hear there's an eager market out there keen to buy smartphone images and yours may just be perfect!

STOCK PHOTOGRAPHY

Many photographers – both professional and enthusiast – have derived a modest income from what's known as stock photos: photos of anything and everything that can be used by, say, those looking for photos for magazines, websites and so on. Okay, so unless you've a massive collection of images in a library those incomes tend to be modest, but hey, who would turn down an income stream from doing what you enjoy?

SELLING IMAGES FROM YOUR SMARTPHONE

Demand for images has never been greater and with smartphone cameras you can take a photo and put it up for sale almost immediately. What is it, though, that would make an image from your smartphone saleable?

It's difficult to say, but some are more so than others. Newsworthy content is always a safe bet for an instant sale, as are shots of famous people, particularly in unusual situations. But don't discount the more everyday images. Newspapers, magazines and websites are always looking out for images to illustrate features. Travel companies want new or novel images from the locations they fly to for illustrating their brochures and websites. And that's just the start.

Tourist shots: sharp, well-saturated shots of tourist locations can sell to tourism websites and holiday brochures.

The prerequisite, no matter what the subject, is that the photos are technically top notch. Creative shots do sell, but shots that are blurred or badly composed just won't hack it. Nor will those that have too many effects applied, unless they are something very special indeed.

TAKING IMAGES TO SELL

There are many agencies and image libraries that deal in smartphone images, and they all provide apps that let you shoot images to their specifications (i.e. of the highest quality) and then upload them.

Before you upload them, you'll need to tag them with keywords – the descriptive words that define your photo. You need to provide as many as possible so that your image is uniquely described. You want a potential purchaser to find your images so make sure you provide as many relevant tags as you can, to cover as many search eventualities as possible. See the next page for some examples of tagging.

COMPLETING THE SALE

When someone finds and buys your image they'll be credited to your account with the respective agency. Don't expect large sums, but find a saleable subject – or subjects – and those small amounts soon mount up. And you can withdraw them though Paypal or other similar payment systems.

Stock photos: 'anonymous' shots like these can be used in a wide range of situations so can prove steady sellers with the right placement.

IMAGE SELLING APPS

Here are some of the apps worth checking out for selling your images. Some even issue 'picture calls': based on your location they'll point out local events and the like and encourage you to upload images.

Fotolia Instant
Scoopshot
Foap
Stockimo from Alamy

TAGGING YOUR IMAGES

When you tag your images it's tempting to include just the obvious terms relating to your photo's subject. That's selling yourself short. Include more terms – which are still relevant – and you'll make your image more saleable. Here are the key topics to consider when adding tags:

• Descriptions of the subject: what your photo is actually showing. Use all the alternative names that might apply.

• Location: where was it shot? Not just the place name, but where that place is, all the way up to country.

• Key colours: what colours predominate, or are prominent in the photo. Some people will search for images with a particular colour.

• Weather/seasonal info, if relevant: if your shots are outdoor, note what time of year they were shot and the weather. If it's a special time of year – Christmas, for example – mention that too.

• Associated tags: if you've shot a subject with an association with, say, a person, include those details. For example, mention Capability Brown in the tags associated with one of his landscapes, or Antonio Gaudi with photos of his creations in Barcelona. Include, too, words that might be colloquially or incorrectly applied. In the example here 'boat' and 'ship' are used to describe a vessel.

• Apps may ask if there are people in the photo (and sometimes how many). Another criterion by which people search. And you could be asked if there are buildings featured. An odd question, but some buildings have copyright restrictions which mean that any shots featuring them can't be sold for certain uses.

Here are a couple of photos along with the tags that might be attached. They are probably not complete: you might be able to think of more.

Historic ship, SS *Great Britain*, on the River Avon in Bristol: VESSEL, SHIP, BOAT, MAST, STEAMSHIP, DRY DOCK, VICTORIAN, HERITAGE, RESTORED, RESTORATION, SS GREAT BRITAIN, SAILING, TRANSATLANTIC, TRAVEL, ISAMBARD, KINGDOM, BRUNEL, ENGINEER, AVON, BRISTOL, RIVER, HARBOUR, ENGLAND, UK, UNITED KINGDOM, GREAT BRITAIN, SOMERSET, GLOUCESTERSHIRE, SUMMER, MORNING, 2014, SUNRISE, REFLECTION, BLUE

Houses of Parliament, London: HOUSES OF PARLIAMENT, GOVERNMENT, LONDON, WESTMINSTER, RIVER, THAMES, BRIDGE, BIG BEN, CLOCK TOWER, ELIZABETH, ABBEY, PORTCULLIS HOUSE, ENGLAND, UK, UNITED KINGDOM, GREAT BRITAIN, SOUTH EAST, SUNSET, STORMY, UNSETTLED, MAGENTA, ORANGE, MAUVE, PURPLE, NOVEMBER, 2013, REFLECTION

KNOW WHEN TO STOP

There's a difference between including tags that are relevant and those that are more dubious. Relevancy is the important word here: if it's relevant, include it; if not, don't. Quality is more important than quantity, and incorrect tags will just annoy potential purchasers who end up looking at lots of your images. They may well be first rate but if they're not relevant to their brief they have no value.

GETTING SOCIAL

Smartphone cameras have reinvigorated photography. They have brought convenience, easy shooting, easy manipulations and more creative tools than any of us can imagine. And they have made it simple to share our masterpieces using that other phenomenon, social media. Now we're not just shooting photos to enjoy ourselves but many of us, when not shooting photos, are tweeting our top images on Twitter and posting images and stories to Facebook.

Given the popularity of social media – and not just Facebook and Twitter – you won't be surprised to discover how easy it is to share your images quickly straight from your smartphone.

Social media: The growth of social media has played an important role in the growth of smartphone photography.

UPLOADING YOUR IMAGES TO SOCIAL MEDIA

In fact, image sharing has proved so popular you're spoilt for choice – you've multiple ways to get them to your favourite social media site:

• Straight from the phone, using the phone's own software

• Using the export options from some photo apps

• Using the social media's own app

STRAIGHT FROM THE PHONE

The significance of social media generally has meant that the designers of the software that runs your smartphone – the operating system – have made social media links a key feature. That makes it particularly easy to post your images. Easy, that is, so long as it's one of the more popular sites – and that generally means Facebook or Twitter. Or perhaps Flickr.

To send an image, just click on the 'send to' button, choose the image to send, optionally add a message, and then select the destination social media site. That's it. The only caveat is that if this is your first time sending an image you'll have to make sure your phone is linked to the relevant social media accounts – but that's as simple as logging in to your account.

Straight from the phone: Post your images – and any comments – to a major social media site direct from your phone in just a couple of clicks.

EXPORTING FROM A PHOTO APP

Some photo apps such as Photogene (iOS) not only let you do plenty of image manipulations but also give you the ability to forward those creations to the top social media sites (a larger selection than available direct from the phone). You'll also find other destinations – such as email or Dropbox – where you can forward your image.

Size can be important when sending an image to social media and these apps will let you choose an appropriate size. For example, if you want to send someone a high-quality copy of your photos you can send them in their original format. If quality isn't so important, you can send a smaller, lower-resolution copy. You might consider doing that too if your smartphone's data plan is limited. Sending smaller images could dramatically cut down the amount of your allowance you use up and limit any extra costs you might be liable for.

USING THE SOCIAL MEDIA'S OWN APP

Each popular social media site (and quite a few of the less well-known) offers its own fully fledged smartphone app. You probably use some of these – such as the Facebook and Twitter ones – to access those media on your phone, as they generally give you the best experience of using the media compared to the standard browser-based version. You can, however, select the images you want to upload

and do so in much the same way as you would on the full version of the website, adding in any comments or notes.

Spoilt for choice: Some apps (such as Photogene, here) offer a wide range of social media – and other – sites for your to export photos to.

POPULAR SOCIAL MEDIA AND SHARING SITES

Where might you want to upload your images? Fans of Facebook and Twitter please bear with me, here are a selection, including the more popular locations – and not just those two – to post and share your images and what they offer:

FACEBOOK

Share individual photos or use photos to accompany stories that you might be posting. You can also post whole albums of images and annotate them individually.

Facebook gallery: Facebook is a simple way to share your photo galleries with friend or more widely, if you choose to make them public.

TWITTER

Attach photos to illustrate your tweets – all for the price of losing a few characters in your tweet. Tweet the image and any caption to all your followers or add some relevant hashtags (a bit like metatags or keywords) that others can search for.

GOOGLE+

Seen by many as Google's answer to Facebook (and, at the time of writing, second only to Facebook in terms of active monthly users), it offers similar options but is also closely linked to Google's other products and services and offers other links to members' online content.

INSTAGRAM

Popular photo and video clip sharing site with intrinsic social media tools and the option to post onwards to other social media sites. Images are restricted to square format – either taken in this format if shooting from within Instagram or cropping your standard 16.9 format images from your library. You can also apply filters before posting.

FLICKR

Popular image-sharing site that's a great way to show off your best images and also discover the best photography of others. To get the best from it, you need to add keywords and give

your image a title; this will let others discover your images. Similarly you can search out other images on subjects or topics you want to explore. There's a social element to Flickr which lets you connect with others Photostreams (by adding them as contacts) and joining in subject-based Groups.

PICASA

A similar offering to Flickr, from the Google stable. It offers modest image manipulation tools too, though if you're in the Google Apps environment you'll also have access to the browser-based version of Snapseed. Along with Flickr it's worth being aware of usage limits, particularly if you are a prolific poster of images (limits do vary from time to time so it's worth checking the up-to-date limits on the respective websites).

DROPBOX

Not socially adept in the manner of the previous offerings, Dropbox is a convenient way of sharing your image collections (rather than individual images) with others. Dropbox content is stored in the cloud and you can choose who to share your content with. Great for sharing and storing really large numbers of images. The basic tier of content is free and you can buy additional space, according to your needs, at a pretty sensible price. Carousel by Dropbox is a feature dedicated to storing and sorting your images and making

them more widely available with the option of modest social interaction.

TUMBLR

A blogging – or microblogging – resource that lets you post images or video along with modest blog/stories. Put simply, it sits between a Twitter-like social media site and a more formal blogging service.

Carousel: Carousel has given Dropbox a more social way of sharing the images stored.

AND FINALLY...

At the start of this book I intimated how smartphone cameras had brought a new dynamism to photography yet the hardware had reached a level of maturity that ensured they were also capable of what we might call more traditional photography.

I hope, as you've worked your way through the book, you've come to appreciate the versatility of the smartphone. In particular how it can offer the photographer – whether serious or more casual – so many opportunities, whatever your style of photography.

Get a proper camera! Once the user of a smartphone camera would have been dismissed by those that consider themselves 'real photographers'. They would sneer at their diminutive camera phones and set to recording the same subjects with more substantial cameras. Now it's not unusual to see those same photographers armed with a smartphone and actively extending their portfolios in ways that with their conventional kit would be impossible.

There's no doubt the advent of the smartphone camera has brought about a step change in photography and a new level of creativity. Okay, so sometimes that creativity means that we are forced to endure images that are not by any stretch of the imagination artistic, but does that really matter, if it's enjoyable? No. And I do hope in using this book you've discovered just a few ways you can extend the fun and creativity you get from using your camera phone.

Thank you for reading. And why don't you post a few of your best – or your favourite – images online so we can all see?

ESSENTIAL GLOSSARY

It's easy to be a bit presumptive when writing about smartphone photography and assume anyone reading will have a good knowledge of the inevitable jargon involved. I've tried – as best I can – to use as little as possible and explain terms as I've gone along. Just in case you missed any of those explanations, or I've been a bit remiss in my definitions, here's a glossary of those essential terms.

ANDROID OS

An open source operating system for mobile phones and tablets and used on the majority of smartphones not using iOS.

APERTURE

The opening in a camera lens that allows the light through. Some have a fixed-size aperture whereas others can be varied to allow in more or less light to vary the exposure and depth of field.

APP

Short form of 'application', generally used in the mobile world to describe small software programs designed for a specific purpose or with specific functionality.

AUTO (EXPOSURE)

An exposure mode where the aperture, shutter speed and sometimes the image sensor's sensitivity are varied automatically to give the optimum exposure.

BURST MODE

Exposure mode that allows several photos to be shot in close succession. Often used for recording fast action.

CONTRAST

The difference between light and dark tones in an image; increase contrast and you increase the separation between the dark and light tones in the image, making shadows deeper and highlights brighter.

DEPTH OF FIELD

The amount of a scene in front of and behind the subject that is in sharp focus. Varying the aperture will affect depth of field: smaller apertures increase the depth of field, larger apertures produce a narrower depth of field (useful in rendering a subject's background out of focus).

DIGITAL NOISE

Grain-like structure seen in shadow and dark areas of an image due to small electrical fluctuations in the image signal being rendered visible.

EXPOSURE

The overall amount of light that arrives at an imaging sensor. Too much light will lead

to overexposure. too little, underexposure. Exposure can be varied by changing the aperture or the shutter speed.

FILTER, DIGITAL

An effect that is digitally applied to an image. Many apps feature single or multiple filter effects.

FILTER, CAMERA

A piece of glass or optical plastic placed over a camera lens to modify the image, for example to produce a tint or to cut out reflections (polarizer).

FORCED PERSPECTIVE

See Tilt Shift.

GEOTAGGING

The process of attaching (in the digital code) a geographical location to an image, drawn from the smartphone's GPS positioning system.

HIGH DYNAMIC RANGE (HDR)

Optical process that combines the optimum image elements of a correctly exposed, underexposed and overexposed image to create a single image with an enhanced range of tones. Can be replicated/simulated by smartphone apps.

IOS

The operating system used on Apple iPhones and iPads.

MACRO

Extreme close-up photography. Some smartphones can offer mild macro photography unaided, but for most smartphones macro adaptor lenses are available.

MULTIPLE/MULTI EXPOSURE

Combining two or more exposures on a single photo. Can also be done by combining two or more photos from the smartphone's photo library into a single image.

RED-EYE

An unfortunate side-effect of using flash lighting from a flashgun close to the lens axis (as is the case on smartphone cameras). Caused by the flash light reflecting from subject's retinas. Can be fixed using a red-eye removal app or (less successfully) by using a red-eye reducing flash mode.

RULE OF THIRDS

Well-used compositional tool that proposes that subjects and important elements in a scene are placed on imaginary lines that divide the photo in thirds vertically and horizontally. Some camera apps will overlay a Rule of Thirds grid on the smartphone's screen.

SATURATION

The amount of colour in an image. The greater the saturation, the more vibrant colours appear. Colours that are already bright will become more so when saturation is increased, compared to colours that are saturated before adjustment. Brightness and contrast tend to increase as saturation is raised.

SELF TIMER

Shutter release option that takes the photo a specified number of seconds after pressing the release. Useful for getting in on the action yourself or for reducing the risk of camera shake.

SENSOR

Light-sensitive electronic device comprising (usually) millions of discrete pixels that together record an image.

SHUTTER

In a conventional camera, a cover over the film or sensor that is withdrawn or opened to allow light though to meet the requirements of the exposure. In most smartphone camera lenses there is not a physical shutter but rather the sensor is energized for an equivalent period.

SHUTTER LAG

The brief time between pressing the shutter release and the shutter actually taking the photo. In this time, which is brief but significant, the camera will determine the exposure and, if not preset, focus the lens.

SHUTTER SPEED

The duration that the shutter (or virtual shutter) opens to allow light through. Short shutter speeds are used to freeze fast action.

TELEPHOTO LENS

Lens that produces an enlarged image on the sensor, magnifying the view.

TELEPHOTO ADAPTOR

An auxiliary lens adaptor, placed over the existing camera lens to give the same result as a telephoto lens.

TILT SHIFT EFFECT

A technique to reduce the area in a scene that is in sharp focus, essentially exaggerating the depth of field.

TOUCHSCREEN

The screen of a smartphone that permits controls displayed to be activated by a simple touch. Similarly when apps are being used, changes to an image can be enacted by swiping or brushing the screen.

WIDE-ANGLE LENS

A lens with a wider angle of view than the standard lens. Useful for shooting in confined spaces or exaggerating perspective.

WIDE-ANGLE ADAPTOR

Accessory lens attached over a smartphone's standard lens to produce a wide-angle effect.

ZOOM LENS

Lens of variable focal length that can be altered from wide-angle through to telephoto. This can either be a mechanical process (where lens elements change position to produce different image magnifications) or electronic (where a smaller or larger part of the imaging sensor is used to create a more or less magnified image respectively).

INDEX